CW00802563

TROPE

TROPE EDITION

VOLUME V

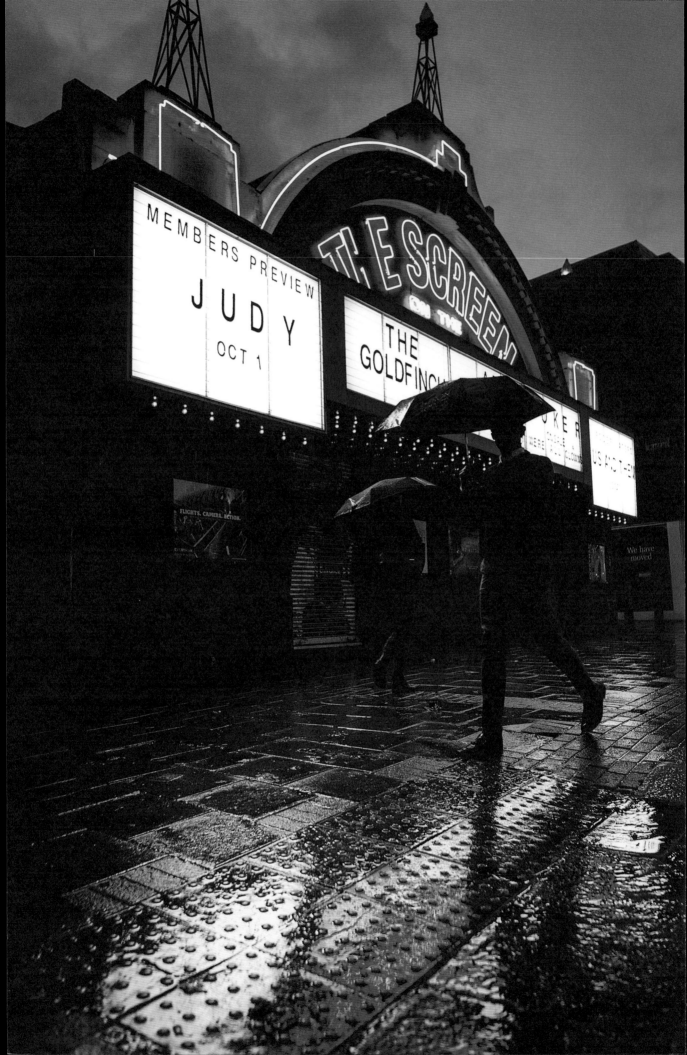

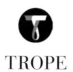

TROPE

CHRIS HOLMES

Hidden in Chaos

TROPE EDITION

VOLUME V

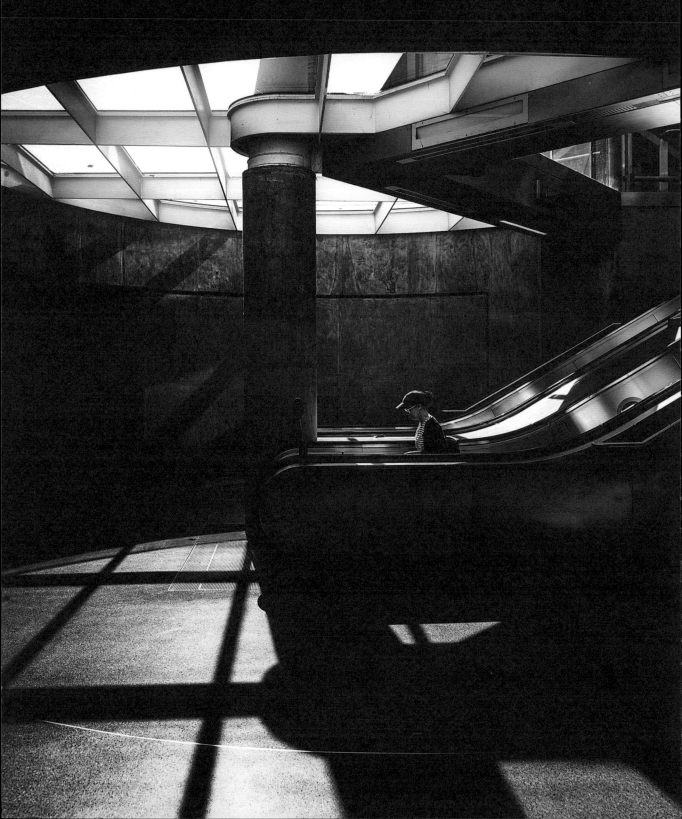

INTRODUCTION

Hidden in Chaos uniquely pairs photographer Chris Holmes' cinematic images with selected poems about London from 18 writers and artists. Chris collaborated with Ash Roye – founder of Music is Remedy, a platform for promoting, supporting and developing hip-hop, spoken word and soul in the United Kingdom – to brilliantly identify and curate the poetry for this edition.

Moving to London as a young adult, Chris eventually began to see the city as a romantic insider and an impartial admirer, often waking before dawn or going out late into the evening to capture intimate moments of solitude and calm. The result is a powerful display of dramatic images envisaged by Chris and uniquely accompanied by 24 poems about life in London. The resulting effect adds layers of texture and meaning to the complex and deeply devoted relationship Londoners and visitors have with the city.

Through Chris's lens, London's gray and glow, and its daily ebb and flow, are celebrated, explored and contemplated in this visual and poetic tribute. *Hidden in Chaos* is the fifth book in the Trope Editions Emerging Photographers Series.

Sam Landers

Editor

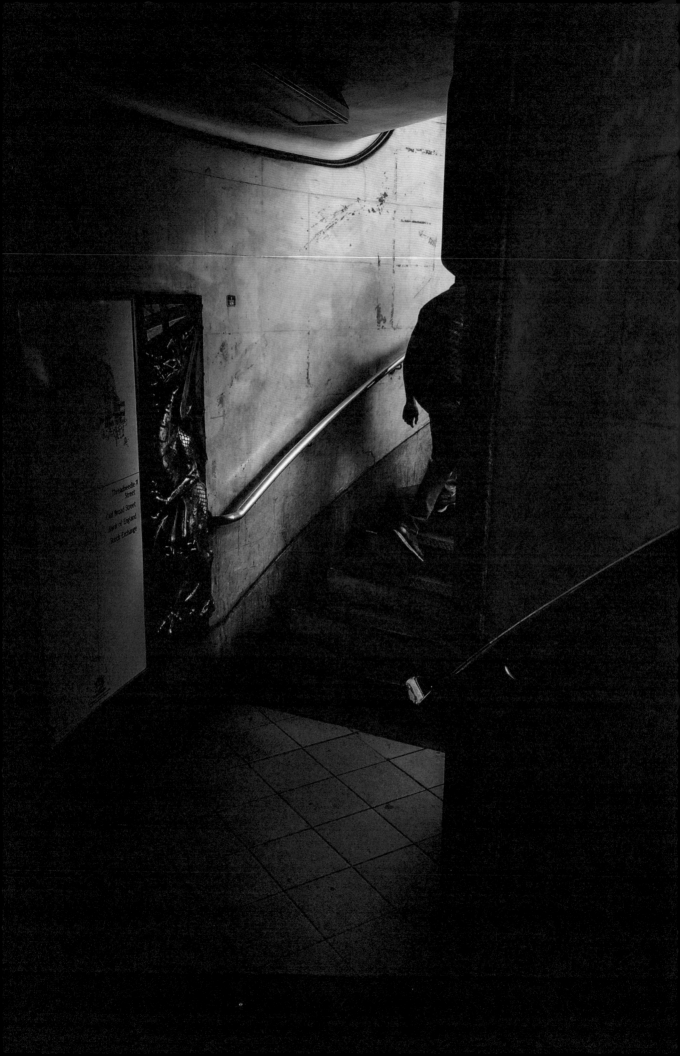

THIS CITY EXISTS TO BE CAPTURED

ASHLEY ROYE

There is something irresistible about London. It pulls in the dreamers, the goal chasers, the corporate climbers, the thrill seekers and especially the creatives. If you are brave enough, it's a hard call to resist. As a member of London's vibrant live music scene, I have been fortunate to work with a number of those creative dreamers. Poets, songwriters, musicians, sketchers... they use their art to tell their stories of the city and their discoveries.

As someone born and bred in the city, it's quite easy not to get caught up in the bright-lights hype and hidden beauty. To take it all for granted. I mean, you don't know any different. London is *London*, the LDN... home. Six and half years ago, fatherhood saw me pack my bags and head east to build a different life for my family, close enough to work in and visit the city, but far enough to no longer call it home.

And now that I'm gone - I get it.

Every time I hit the streets or jump on a form of London transport, my head soaks it all up, breathing in everything the city has to offer. Things that my peaceful village with a church, bowling green and volunteer-run shop (that closes at 5pm) does not. Funny what you can see when your head isn't stuck in your phone.

The grim, grey demeanour that London can give off is exaggerated by every paving stone you walk over. And not just the pavements; the suits too, on their daily commutes to jobs that may see them living for their weekends adding to that London grey and its sometimes grim realities. The solitude of the working commute; headphones on, eyes on screens. Too scared to give

a friendly hello, smile or seat for someone more in need. How can a city with so many, have the ability to make you feel all alone at times? The darkness can consume all. Beauty, however, can be found on every grim, grey corner of London. People do step into the light, offering that seat, saying hello or giving that smile. Other forms of light and beauty also shine through. The storytellers, wordsmiths, musicians and artists bring their creations out for people to engage, dismiss and enjoy, providing splashes of colour, inspiration and joy for people's lives, something that the work of Chris Holmes does daily.

When I met Chris, I thought music would be his creative outlet. Music turned us from work colleagues to friends. We would go out to gigs to watch the range of emerging artists (good, bad and ugly) that you find performing around London on any given weeknight, telling their stories and tales of the city. I encouraged him to drum, and was excited when he found himself in a band creating and gigging. I definitely thought that was going to be his thing. Instead, he put the sticks down and picked up the camera, in the process finding something that actually suited him far better.

In my mind, his ability to use that camera to capture moments in this great, wonderful city - pieces of people's days, a split second of their story - is second to none. He exposes the hidden beauty there to be found. It's how he tells us his tale of the city - through the lens of an adopted Londoner. His images, combined with the words of emerging poets in this book, illustrate his view of the city in his own unique way. The words deepen the narrative; but to be honest, these images are so strong it will make you start taking your head out of your phone to search for your own moments of hidden beauty and inspiration that are everywhere for you to see, and I encourage you to do it.

Chris Holmes' images are a gift. A gift that by turning the pages of this book you will be able to immerse yourself in.

HIDDEN IN CHAOS

MAY I ASK WHO IS STEERING?*

IMOGEN HUDSON-CLAYTON

London,

My Love,

sit back and relax.

Take your foot off the gas.

Enjoy the lost lovers that wander your streets,

and revel in the victories and not the defeats.

Turn a blind eye to the lack of stars that sit in your skyline,

and remain always thrilling and defiantly sublime.

———

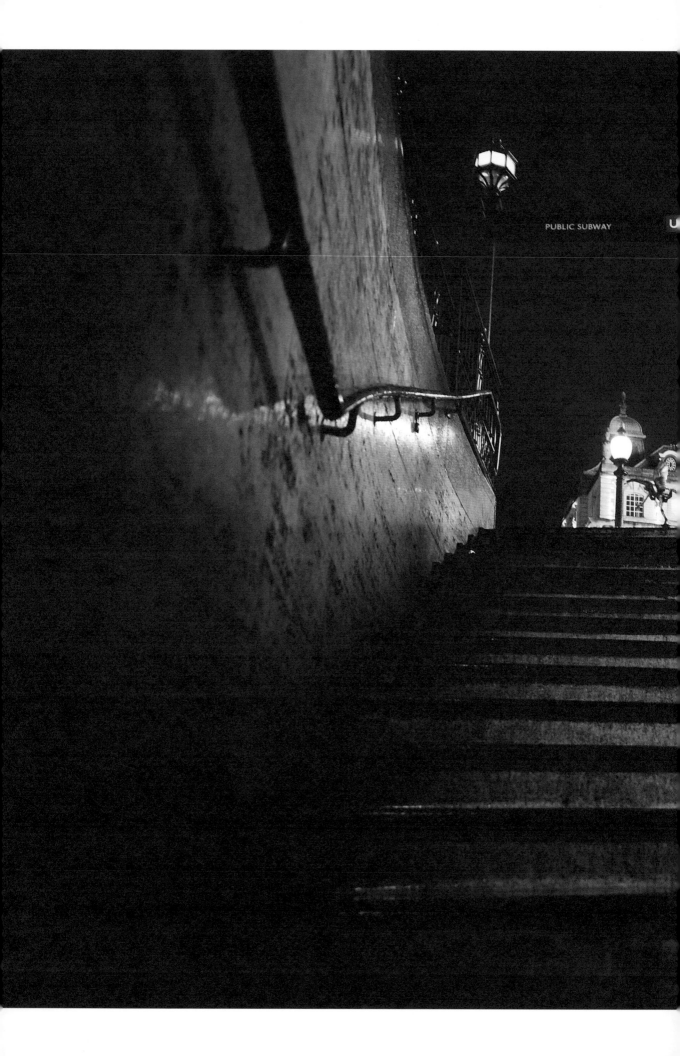

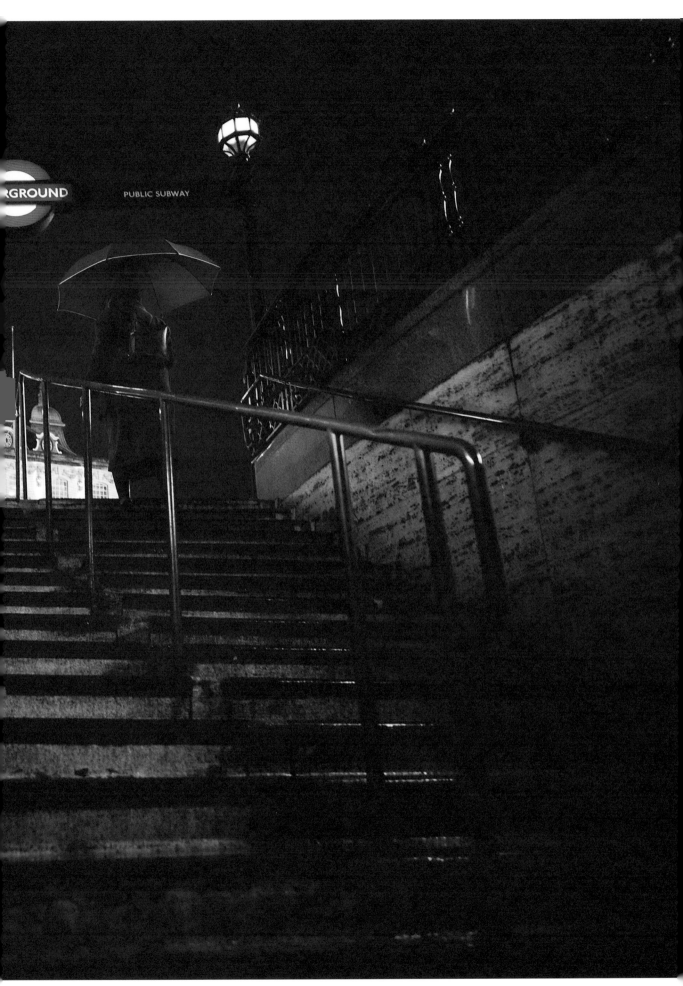

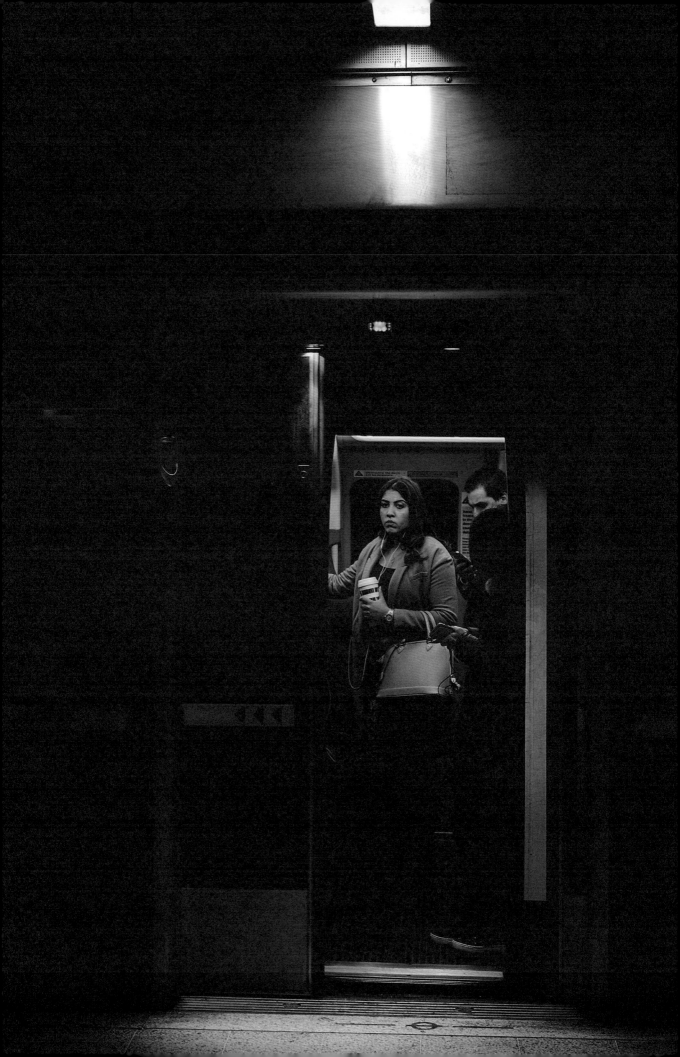

DON'T MIND THE GAP

BIZHAN GOVINDJI

Doors slide open on Monday 3rd.

We rush in over yellow lettering, blurred,

the quickest get a seat and settle in 'til they're disturbed

because no seat's reserved

and yet everyone seems reserved.

If someone speaks to us we're perturbed,

unnerved,

it's just not what we do.

Not here on London's Tube.

Apparently it's rude

to interrupt the solitude

of someone else's commute

with something as minute and innocent as conversation.

I get nothing back but looks of frustration

or disdain and

so I start abstaining.

There's panic on the streets of London.

It seeps down

underground

where it's found

in wordless looks between your eyes and mine.

Tension dances in those furtive glances,

we stand in stooped stoic stances

stumble straight through underpasses

surrounded by people.

Each of them are different chances to connect

and connection enhances.

So if next time

I don't take one of those chances

but chance is on my side,

you might take one

on me.

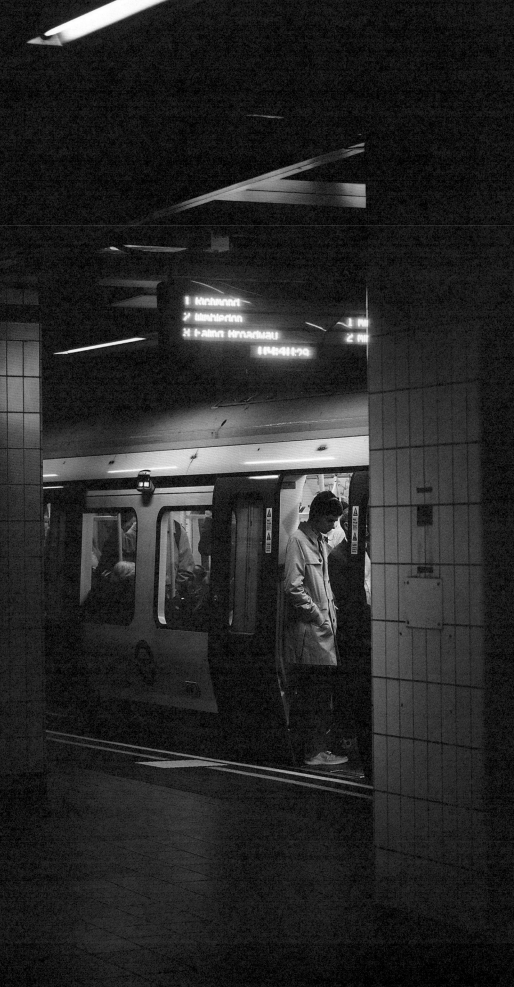

COMMUTERS

ASTRA PAPACHRISTODOULOU

the more the crowd

gathers in silence

the more the stillness

reaches the crowd

mute, it reaches

every corner & far

it reaches - mute

the silence is mute

it reaches more & more

the silence is covered

in varied corners - it

grows & it covers more

& more every time

as it reaches - the larger

the crowd, the larger

the silence - it grows

when all things gather

& the crowd remains

~ mute

———

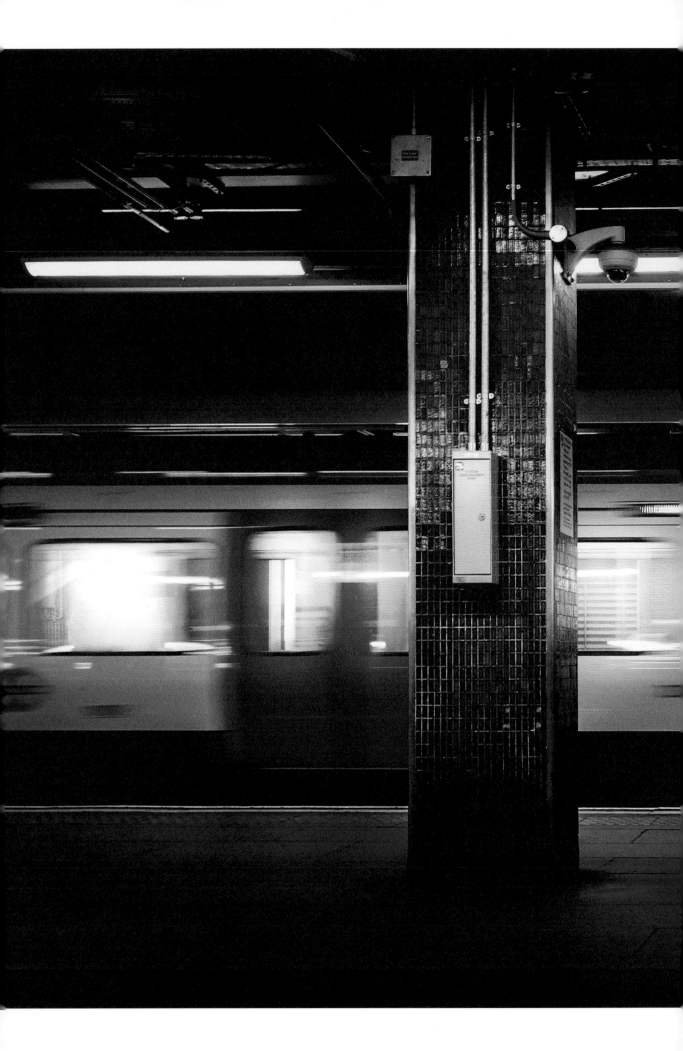

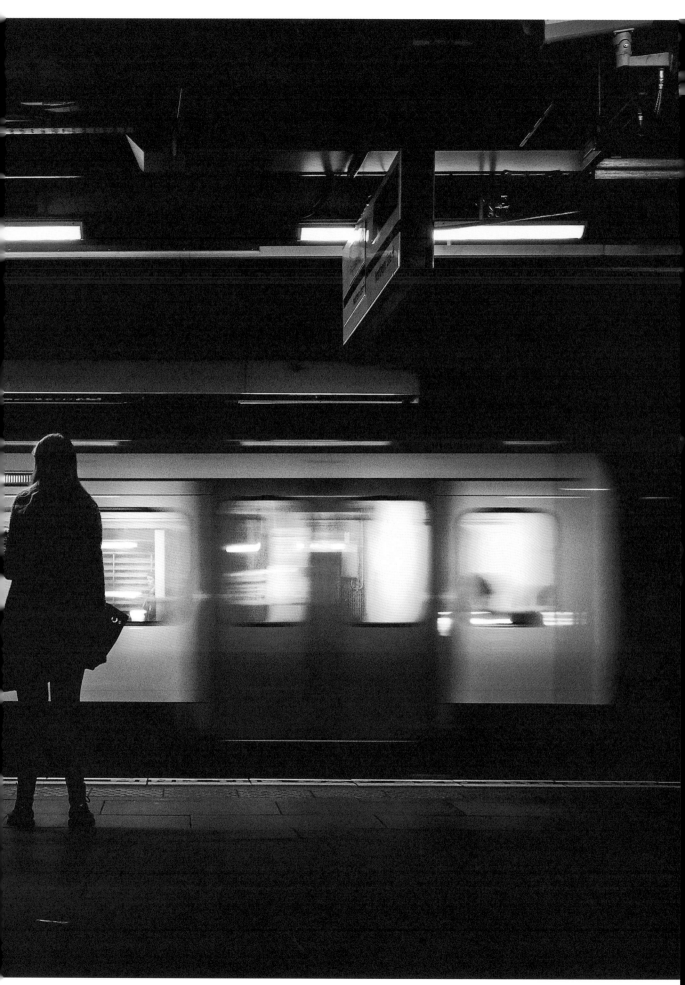

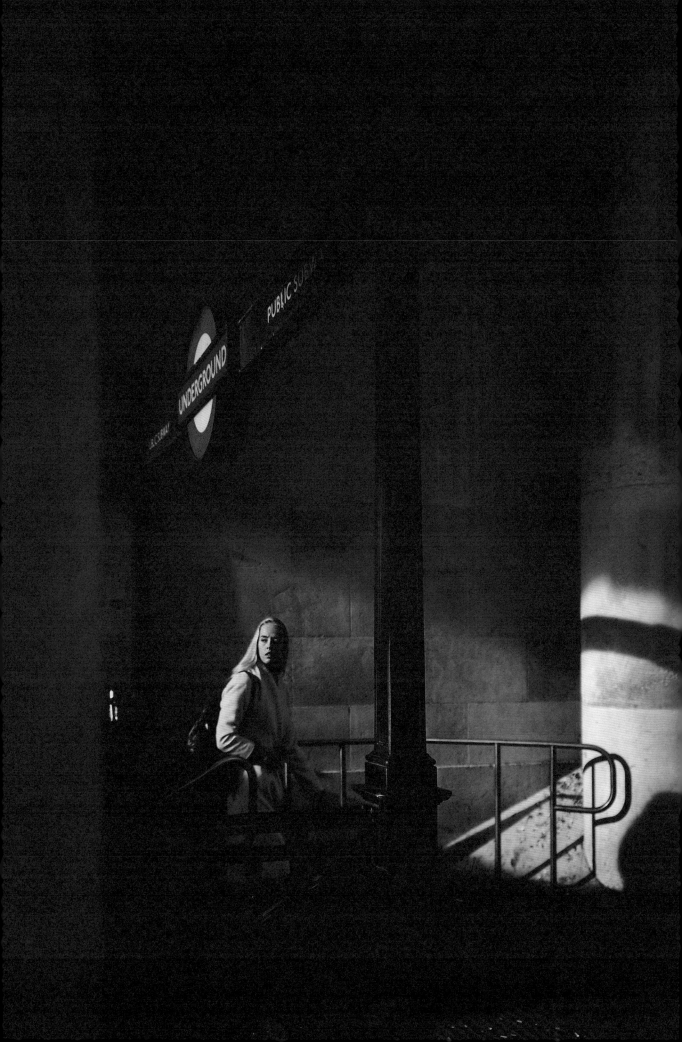

MY ROOM IS BIGGER BACK HOME YET...

AALIYAH ORRIDGE

I never believed it when they said 'you'll miss it when you leave'

'You'll want to come back' they said

The cold will find its way to your bones in the middle of the warmth

and remind you of the memories you made in the cold while trying to keep warm

I believe now,

I lay here on a beautiful tropical island feeding my body relaxation and warmth

Yet my mind runs through your brick streets lined with red busses waiting to take me to

my next adventure

Yet I yearn to clean the small confined space I call a room and to sit by my windowsill

awaiting a knock that will steal my peace from watching the sunset because you are a land

that never sleeps

The view is different there,

Life is different there and I hate the constant rush, but I adore the adrenaline

The skies are in constant war with the sun and not clear blue

The oceans are not warm like a hug from Gaea herself

The sun does not smile back at me and there are no rivers I can go and wash clean on

Sundays it's not home

Yet my mind runs through your brick streets lined with red busses

Yet I yearn to clean the small confined space I call a room waiting to take me to my next

adventure

———

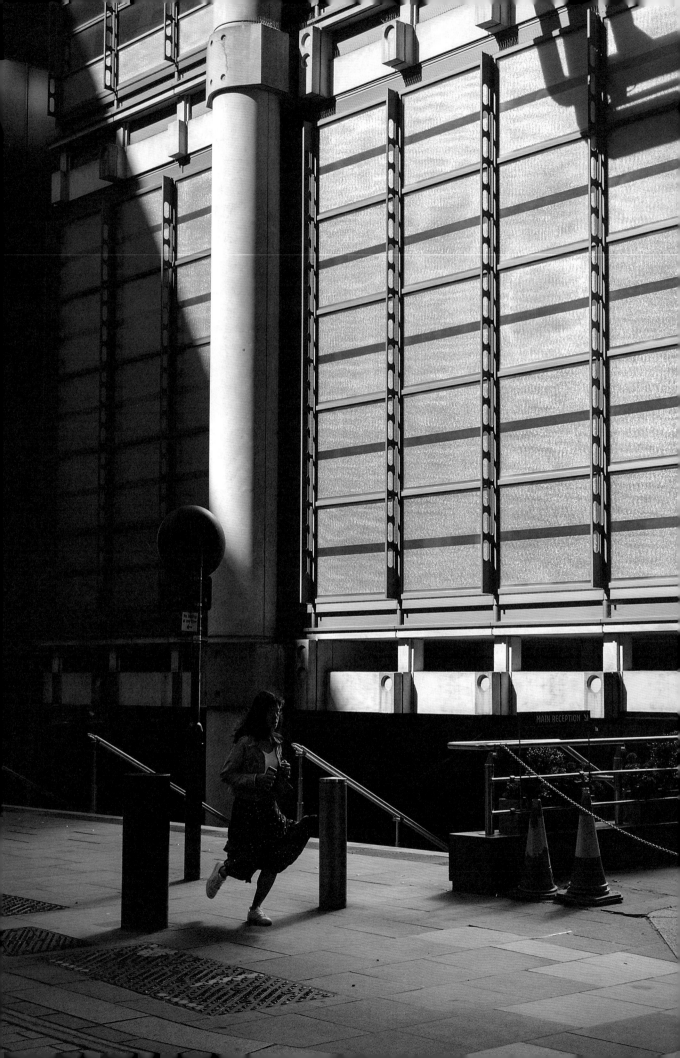

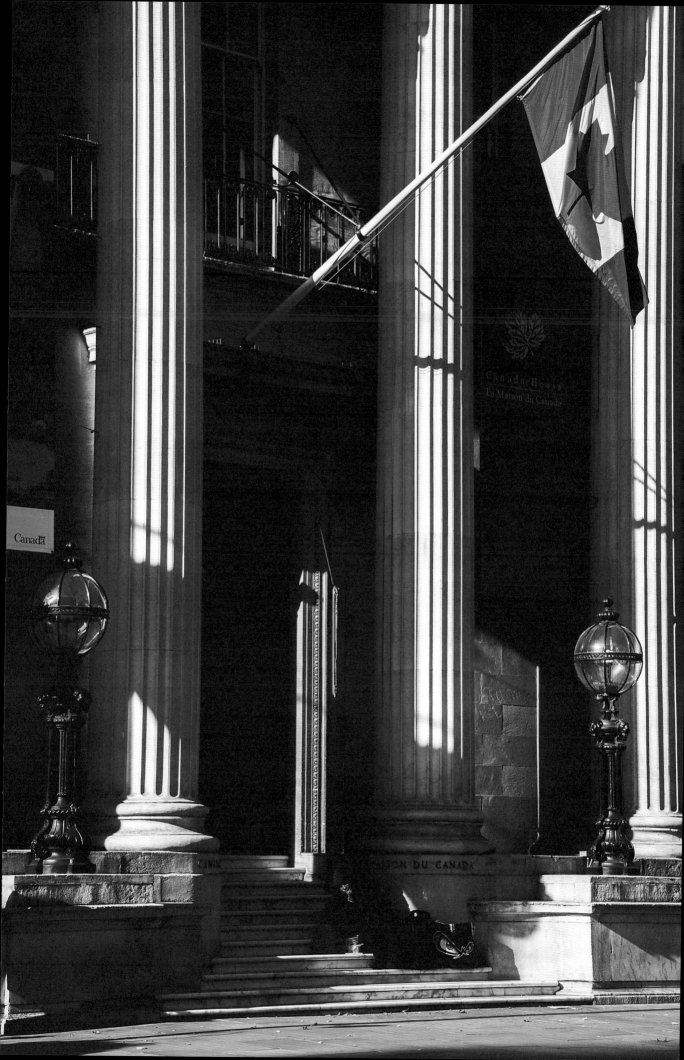

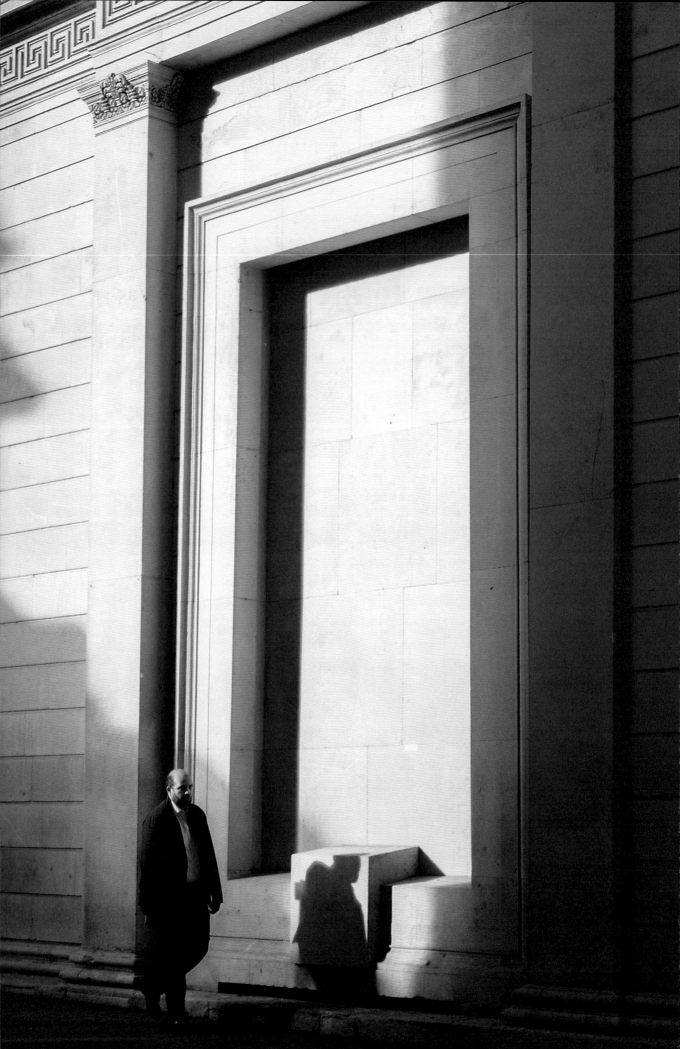

LONDON, MY PORTRAIT

TROY CABIDA

I am an empty beer bottle
left underneath a bench from last night's heart to heart.
There's humour in a drink so masculine
and its ability to make men cry.

I am a marble Medici lion inside a glass window
of a Portobello Road antique shop, waiting for home.

I am a withdrawn library book rendered for sale,
cheap but cheap for a reason:
a broken promise revealing a story
you don't want to read about after all.

I am the 74 stopping at Hyde Park Corner.
The walk from there to Oxford Circus
gave me enough breathing space to visualise
the next four years. All I had to do after that was to live.

I am an iPhone exhaling after a FaceTime session
with the Philippines that house the other half of your heart,
hours melting into heat that prickle the fingers.

I am a Wonder Woman poster
in a bus stop at 6:05pm, glowing bright, untainted truth.
It's been two weeks since it was put up,
and I've never felt more embraced by the city.

I am Putney Bridge
framed by an orange and purple sunset,
yellow freckles of light, a lone boat floating
underneath the river, melting into the night.
This one will never change.

———

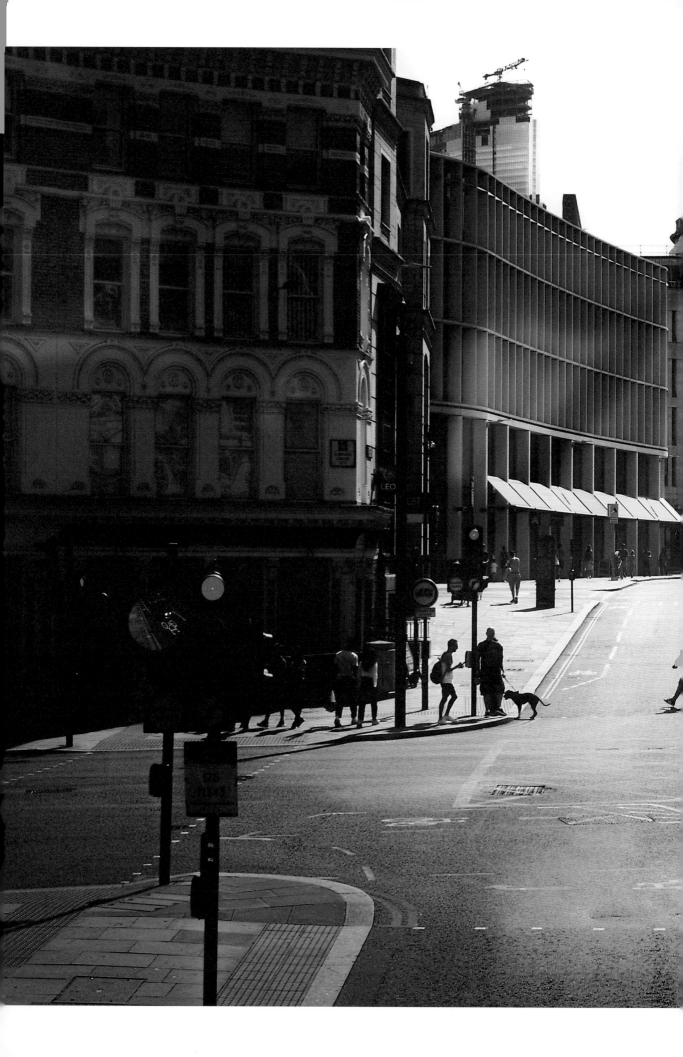

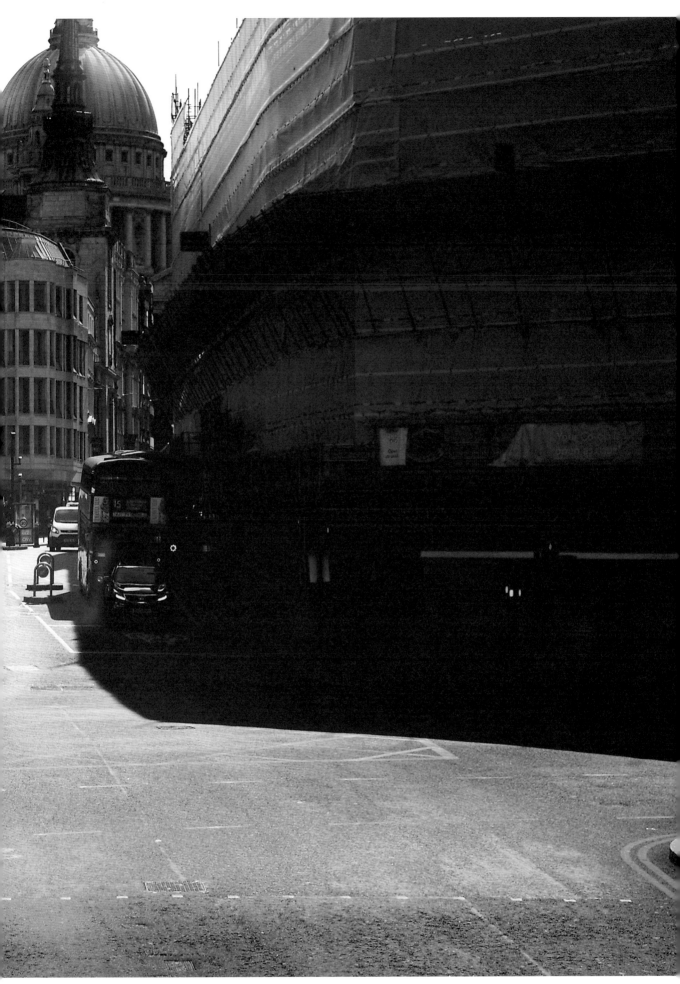

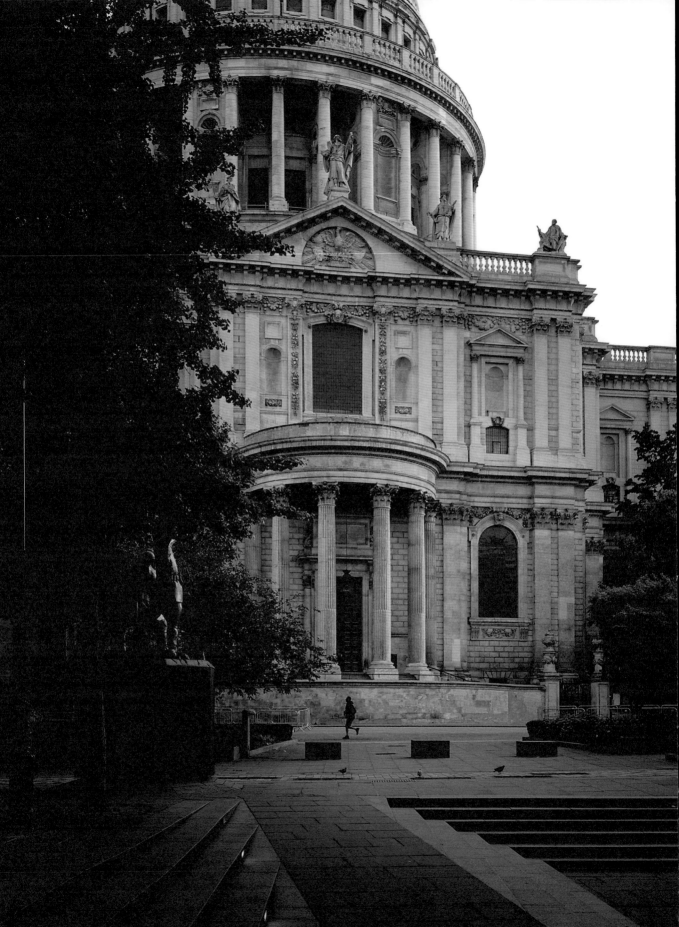

ESTABLISHED

ABDUL PATEL

91, Homerton

You taught me a prince hears a queens heart from the inside

You taught me a Madagascan Warrior would bleed for his tribe but, today, for his cub he cried

The beauty of two cultures mixing and forming a companionship here in London we still remain unified

But overworked parents meant I fell out of their keep to the many temptations of the roadside

98, Dalston

You taught me self-defence on the astro-turf during a mid-game football match

You taught me to raise my voice and banter amongst the market stores whilst having a laugh

And you could never overlook the counselling, disputes and advice in the barbershop between customers and staff

Howard Road; my aunties cooking, shouting, singing, or all at once. So many initial emotions in my nans gaff

01, Gloucester

You taught me about segregated people post 9/11, now I have abandonment issues by my own race

Rejected by whites, blacks and browns

I don't fear the repercussions of believing in my faith

What does it mean to be Muslim? It means growing a beard to hide the scars on my face

It means being human, having a duty of care towards humanity and this sacred thing called life we embrace

04, Grand Baie

My mothers homeland of Mauritius, you taught me survival and I been ready

You taught me colonisation is existent under the name of modernisation for the sake of a penny

You resurrected my mother tongue of creole tu ovier moi l'echair nourishing the food of thought in my belly

But paradise also has horrors, have you ever seen the trenches without poverty

07-09, Stoke Newington-Hackney Downs

You taught me people value bricks and statues more than the life of someone

You taught me maturity is bigger than myself so I point my index finger into the sky to praise the one

But, don't confuse it for gang signs I'm anti-guns

Pro-life. If you get stabbed in London the perpetrator is near impossible to find

But if you drive in the bus lane within 24 hours you can expect a fine

You taught me politics of the street, geography of the tube and history of immigration

You taught me no matter where I am in the world Hackney will always be my foundation

19, Here

I learnt at age 28, a lot of my life was on the road but not much has changed since I spend it in traffic

I visit my nan sometimes but I try to avoid the company of bad habits

So, I take my experience, grit and love for home and wear it like a jacket

You taught me many things,

but I learnt London,

London is where I'm established.

———

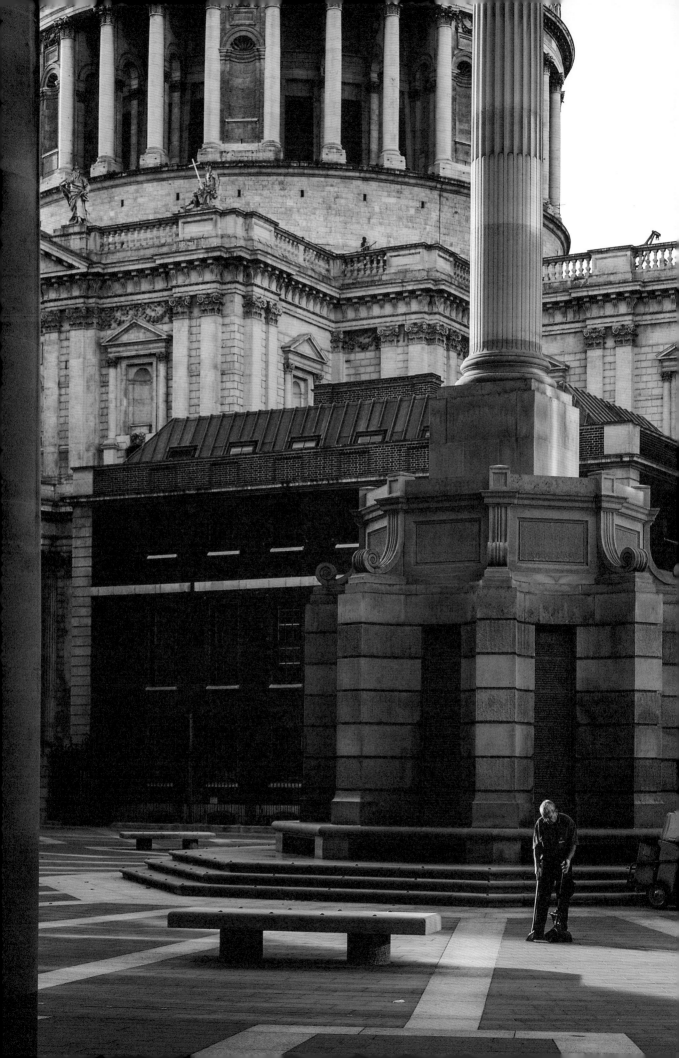

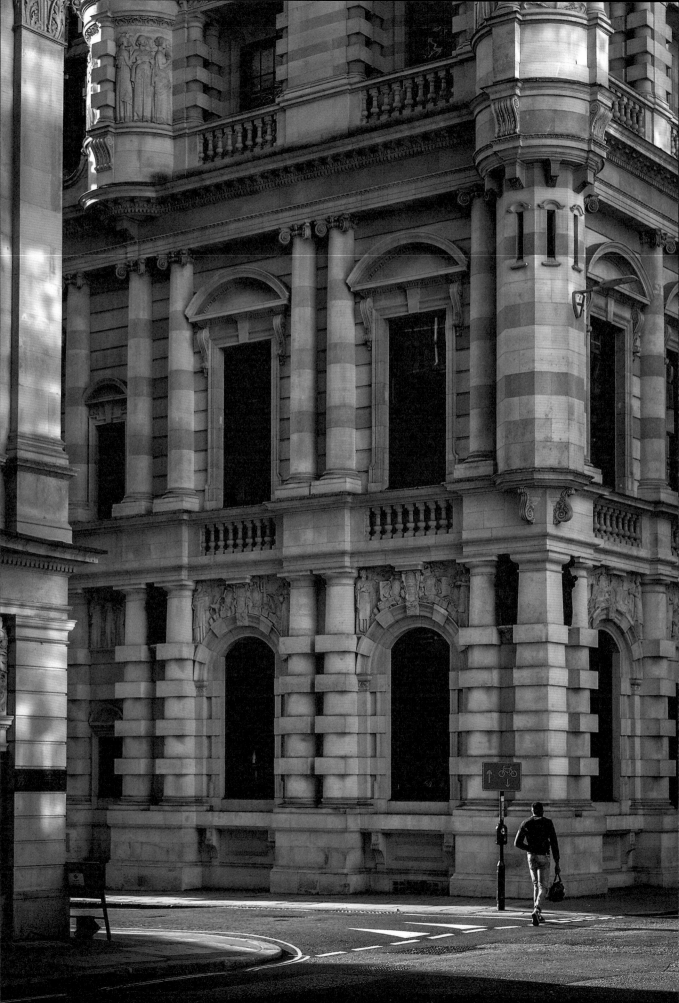

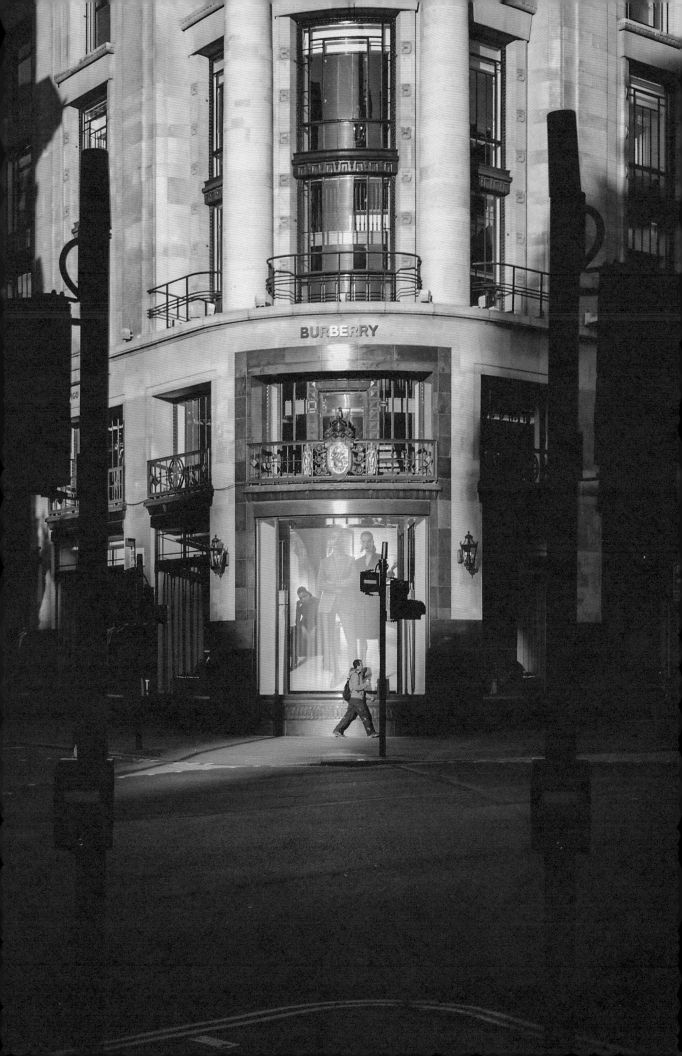

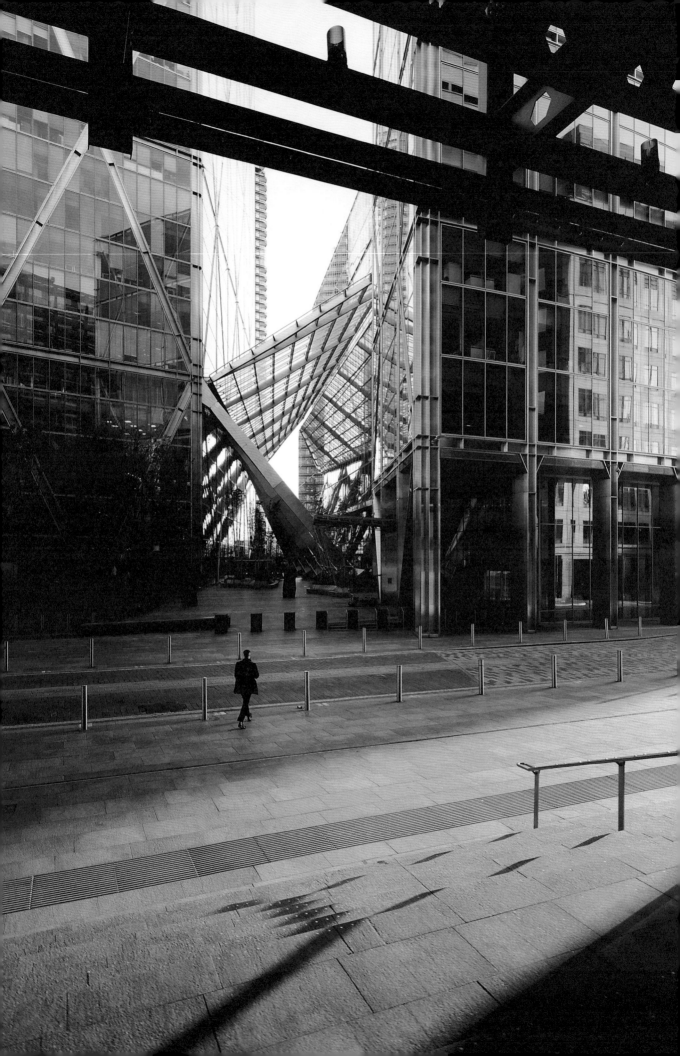

PECKHAM SPRINGS

IMOGEN HUDSON-CLAYTON

Pucker up Peckham

Put on your dancing shoes

The Red Head and the Greek Goddess are coming for you

They will write rhymes within your springs

Their tongues whipping up sexual things.

They will be your slaves.

Arching their backs

To the beats of their inner maids,

As you pick them up

Wrap your Giants hands

Around their gentle necks

Taking them to new lands.

Dowse them deep into your waters

They gasp for air

Forgetting that they once were daughters

Dripping with delight

They forget and find themselves

Joyous in the strength of your might.

They will be your masters.

You will plead with them

And they will only spin you faster

As they pin you down

Tossing you with their eloquence

Blinded you will be

As they tease you with their elegance.

These women warriors will build a language with their bodies and with their minds,

Their fierce softness embracing and chasing you as your wanting manhood unwinds.

Pucker up Peckham

Give yourself to them

They are no longer women, you are no longer men

You are Dancers.

———

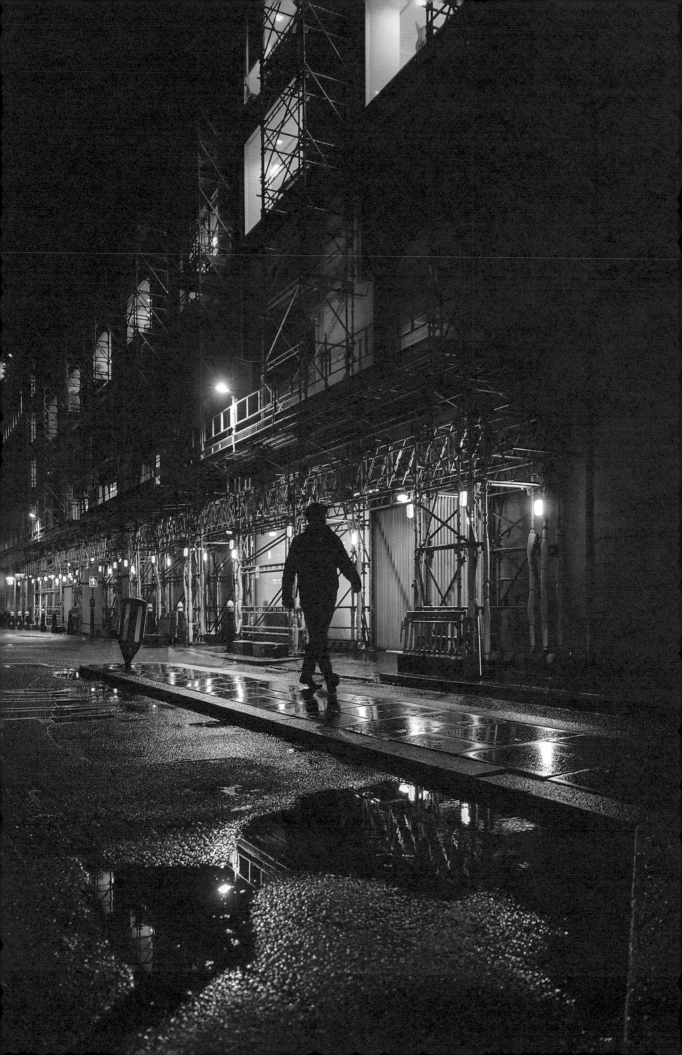

NEVER LEAVE

LAURA CORNS

I miss the Village Underground and how the solid story-filled bricks
bounce the soul and hip-hop sound all around.

I miss how anything you need to find is right there on that street, around the bend,
next to the pub with a club night you've meant for years to attend.

I miss seeing the same faces every day waiting for a train
knowing you will never know their names.

I miss every possibility of passion-packed food
you could ever want or need.

I miss the culture and art dripping from inside buildings
you can stroll around, lost in your own headphone surround sound.

I miss the parks that fill to the brim
at the slightest hint of sunshine.

I miss the rooftop bars, chatting shit with your friends,
so caught up in the moment that you miss the f***ing sunset yet again.

I miss the late-night clubs, dancing to beats you've never heard
till the lights come up and you step outside to the first rays of sunrise.

I miss looking out of train windows in the wintertime
seeing snapshots of lit-up boxes, like motion social feeds.

I miss the realisation you get every few months or years,
to look up and see history towering over the path your feet walk on every day.

The path where you could close your eyes and visualise every chewing gum stain.
Yet when you look up, it's like you are a tourist in your city, all over again.

———

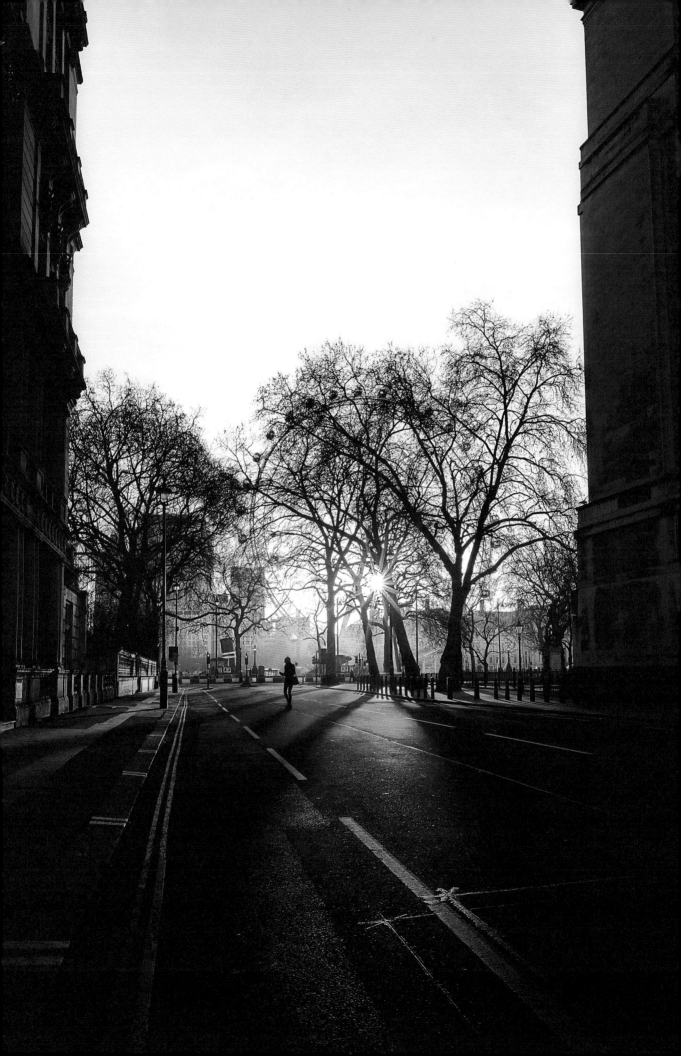

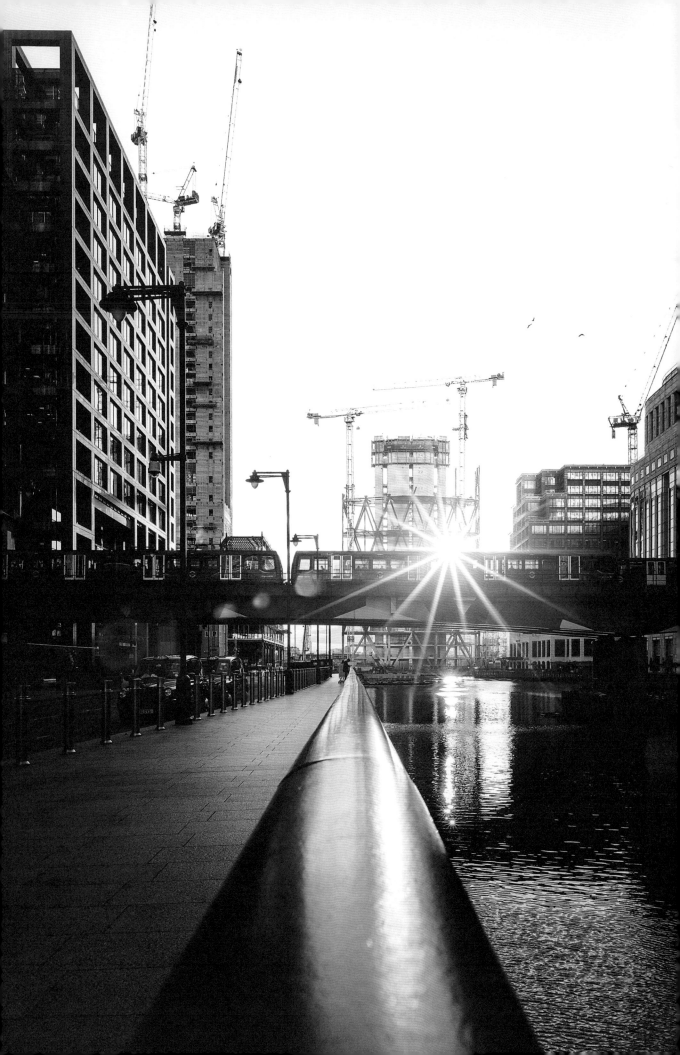

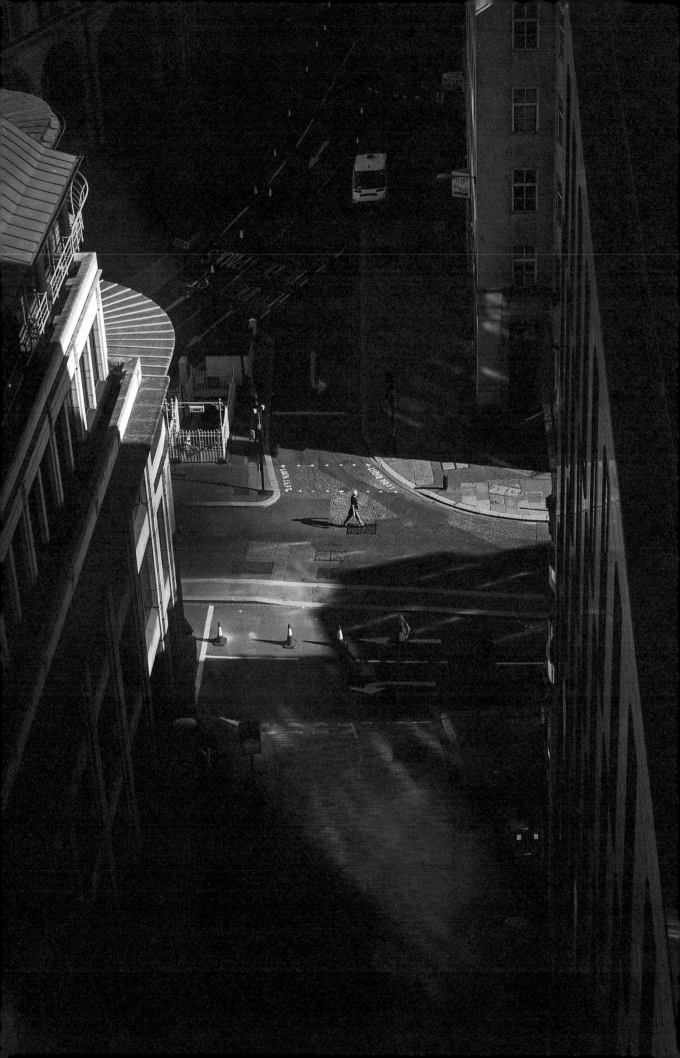

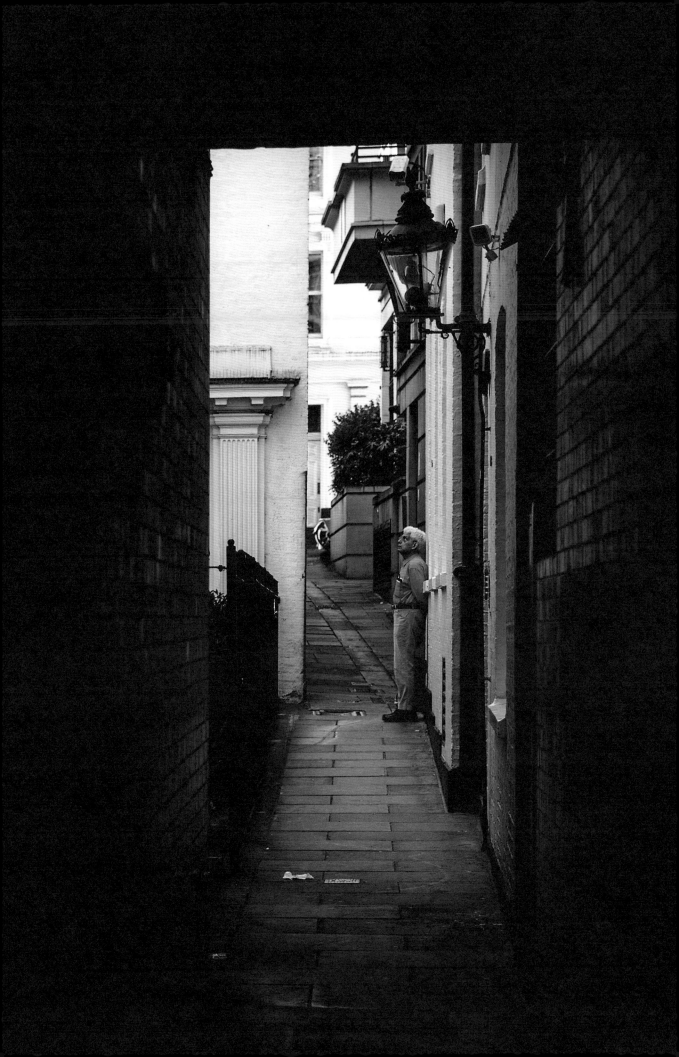

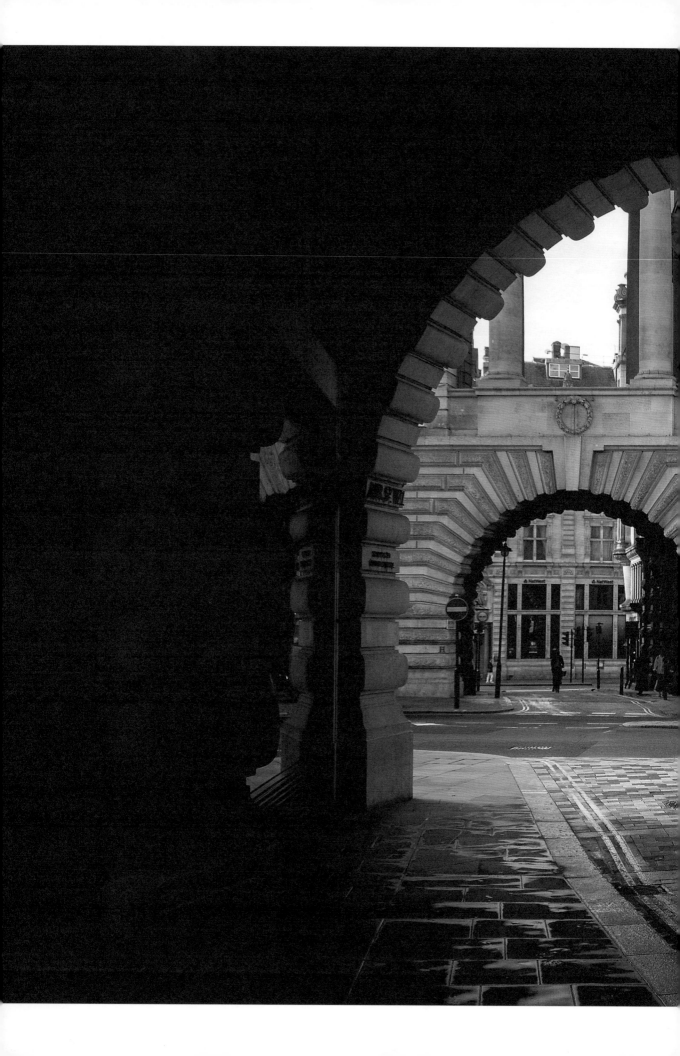

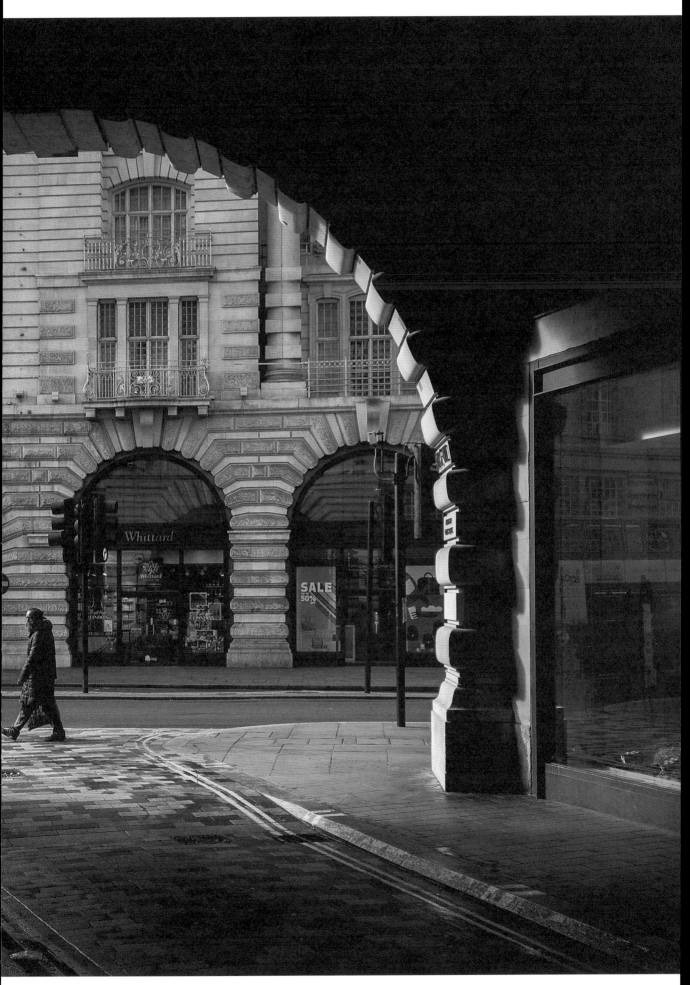

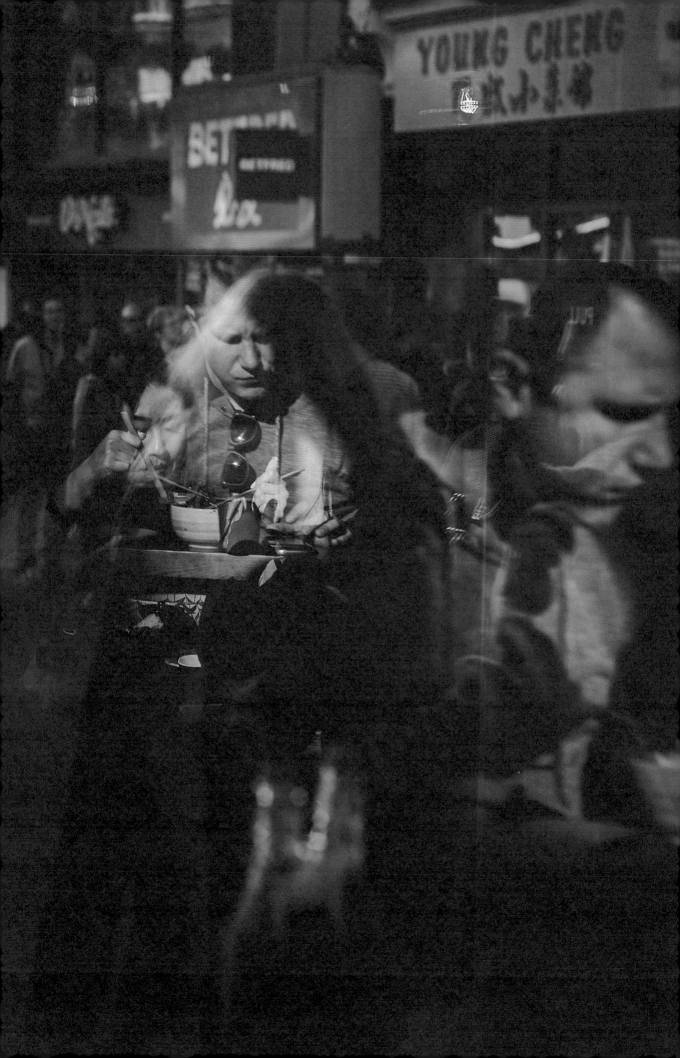

STUMBLING

GEORGE DUGGAN

The ringing subsides,
gives way to footfalls.

Each shoe tumbles to the floor
like all the things we have just lost:

car keys, chewing gum, filters, dignity.

We clutch our headaches,
nestle a sense of anxiety
born of cold sweats and hot nights.

Of amen breaks on endless loop.
Of 7am zoots on endless loop.

Eye contact exchanged between morning commuters and us:
the refugees forced out by the night time.

Of night busses used as ambulances
 and as hearses.
Mosaics of fag butts on bedroom floors.

Of lies told,
mothers cussed,

Best friends belly-laughed into being
in moments that are as unforgettable
 as they are forgotten.

All the change not made,

deadlines scraped

fumbling fingers

 rolling roaches

 through

 vacant eyes

searching for shelter from the new day

again and again.

Sometimes the sunset and sunrise swap lives.

Sometimes, in the space in between, we find our home.

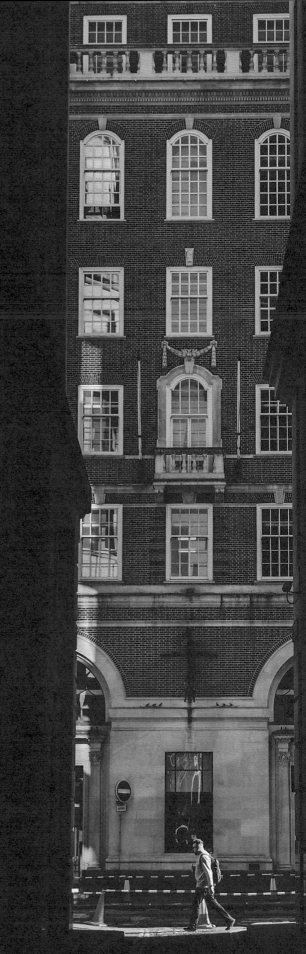

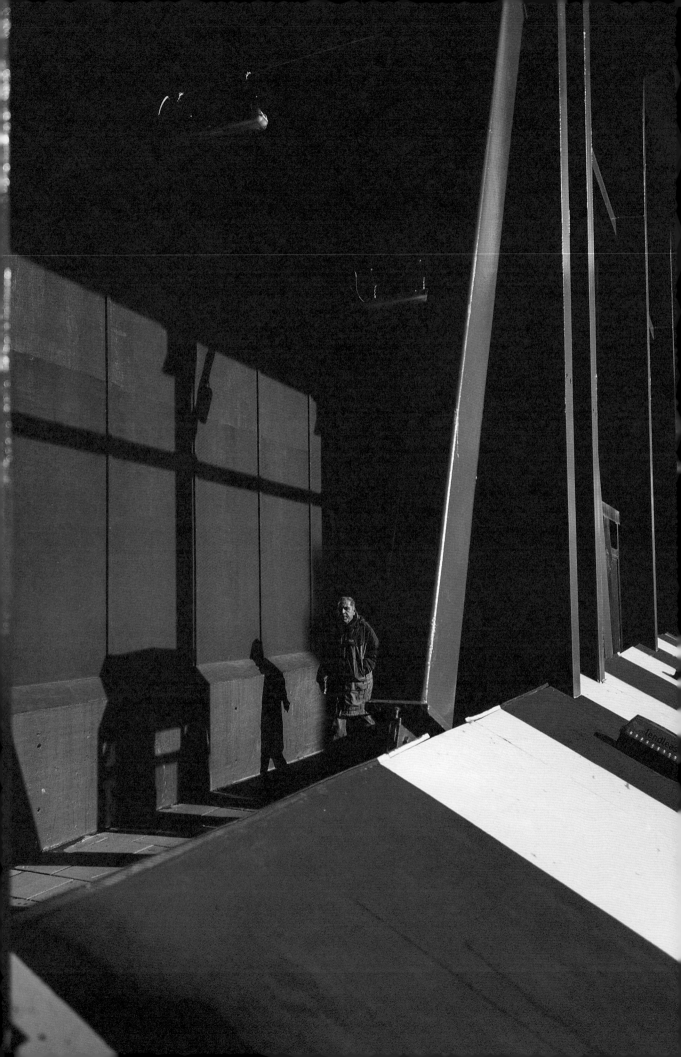

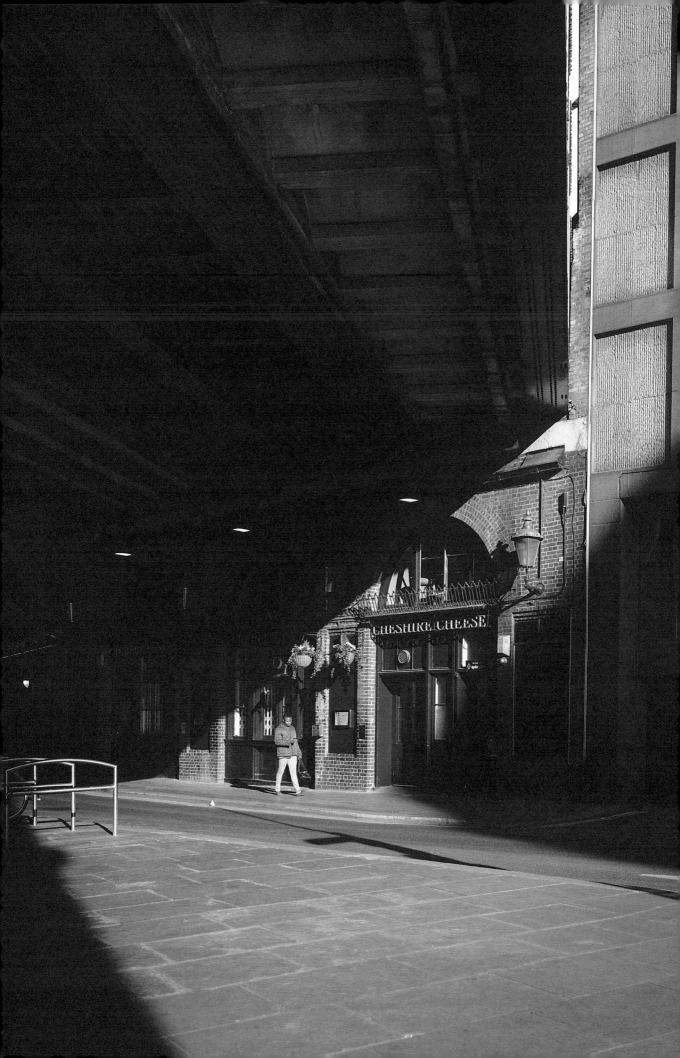

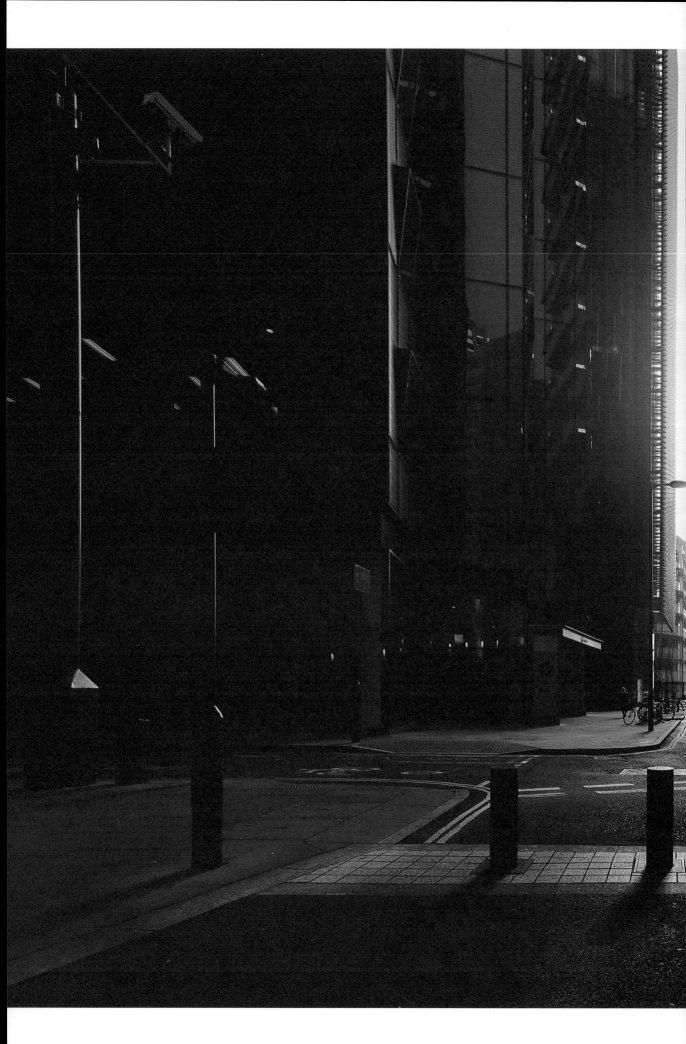

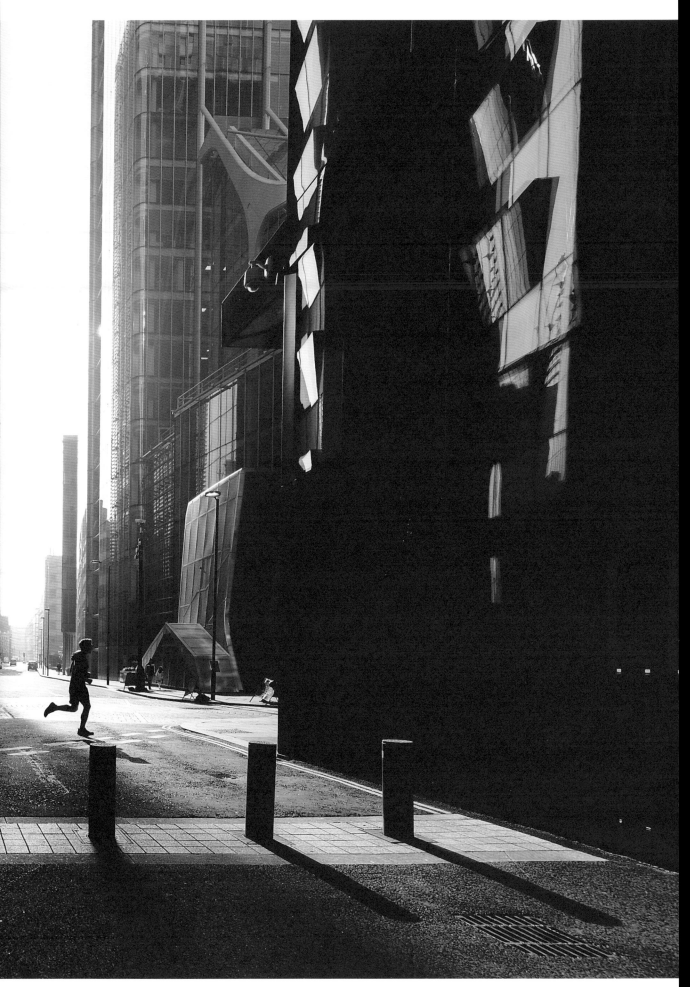

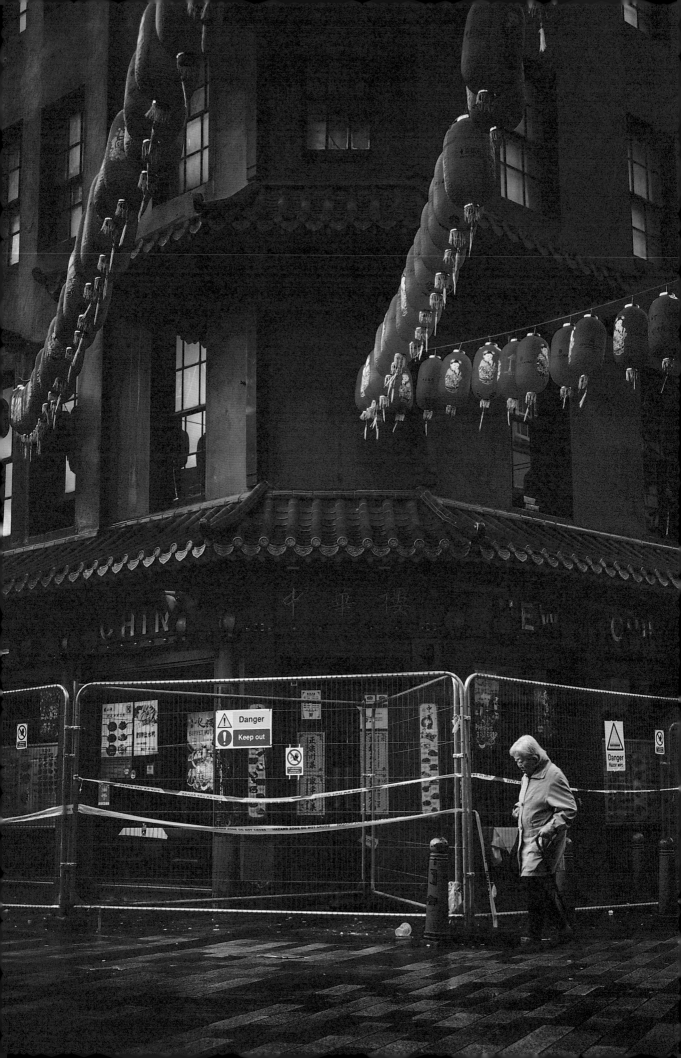

A PASSER-BY CONJURES A WORLD WHERE
EVERYONE HAS THEIR OWN RED DRAGON

ASTRA PAPACHRISTODOULOU

lost in the wild streets:

a cardboard box, coloured

fabric, needle & thread

lost in the wild streets:

a rope of twisted twine

lights & firecrackers

somewhere beyond:

thread and threadiness,

hope in my pocket

lost in the wild streets:

are all things you need

to build a dragon

———

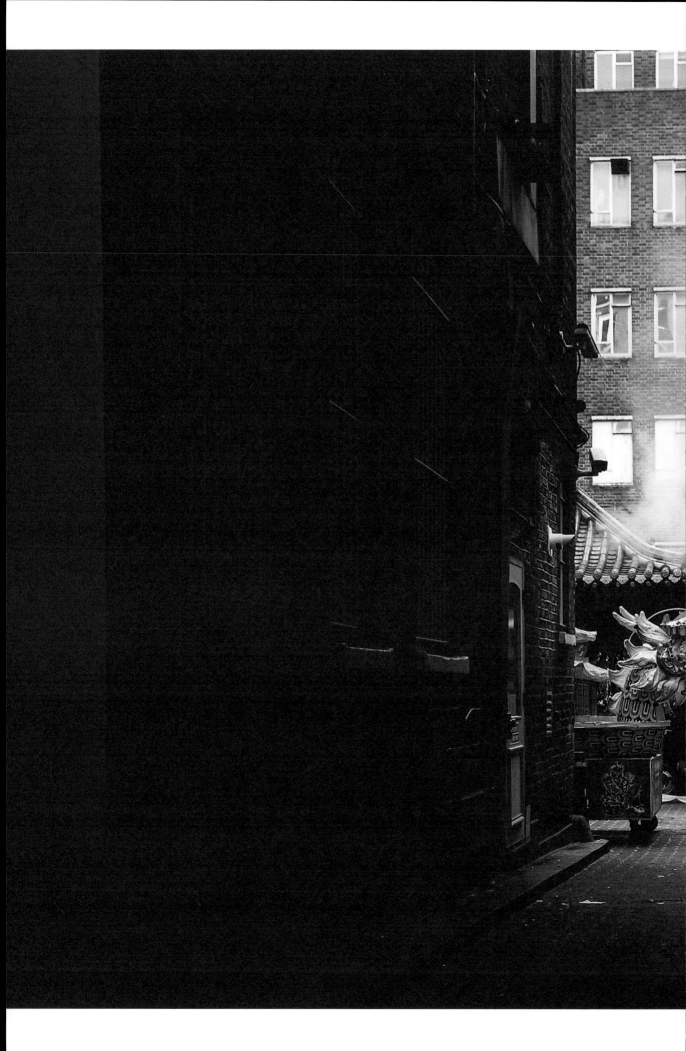

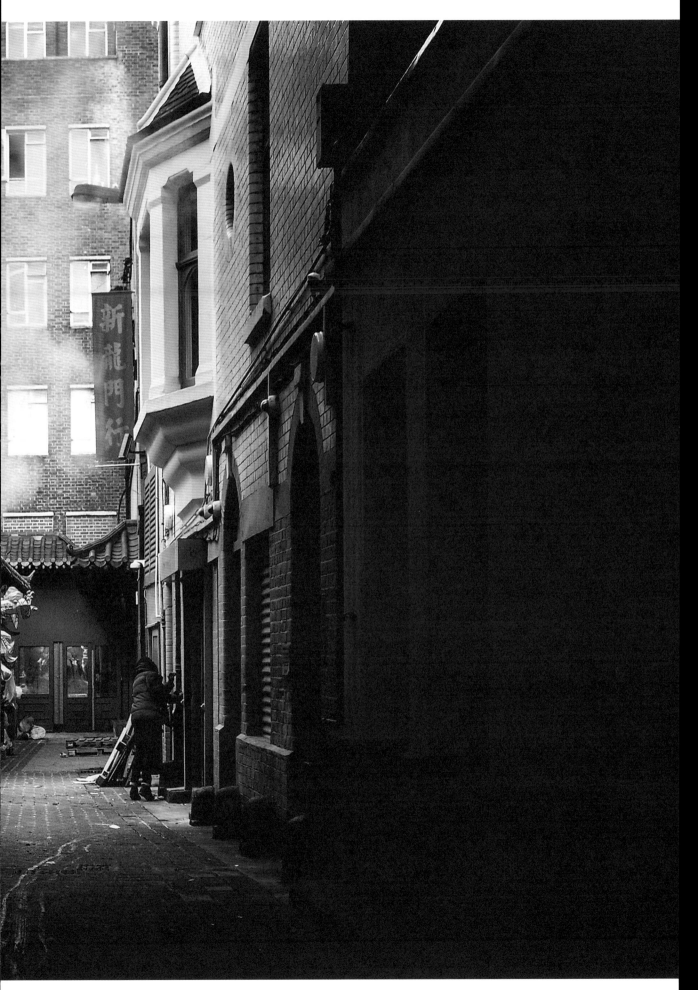

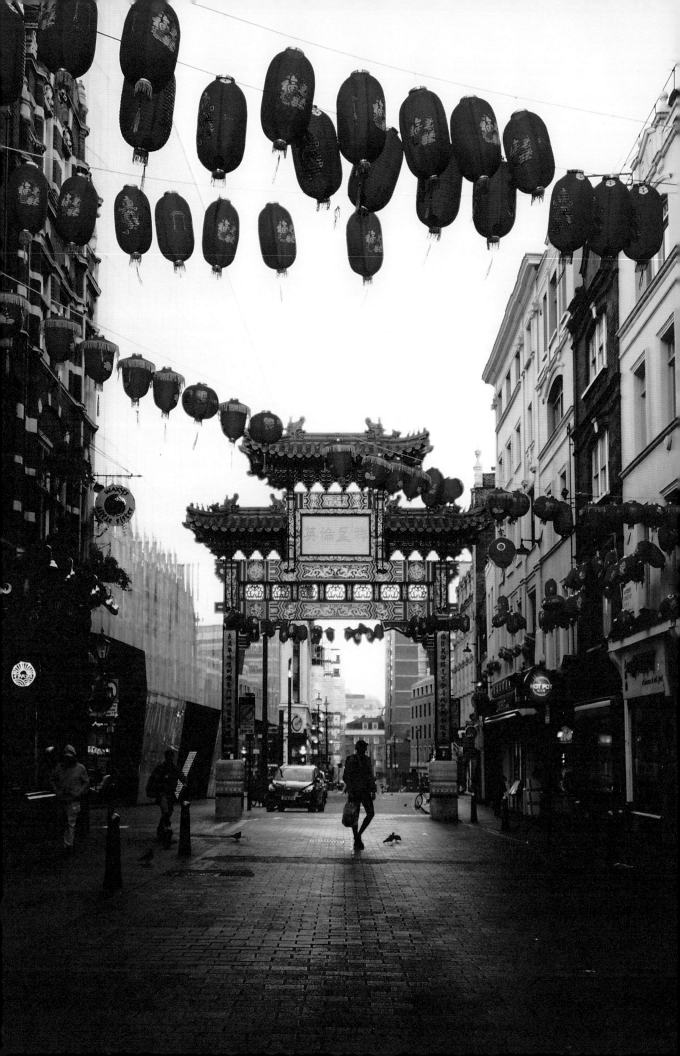

OBSERVING TEMPLES

ASTRA PAPACHRISTODOULOU

as a panopticon ◉

as an evermore force

in his peripheral vision

between lantern & arch

a ray of sunlight appears

to set fire to the streets

———

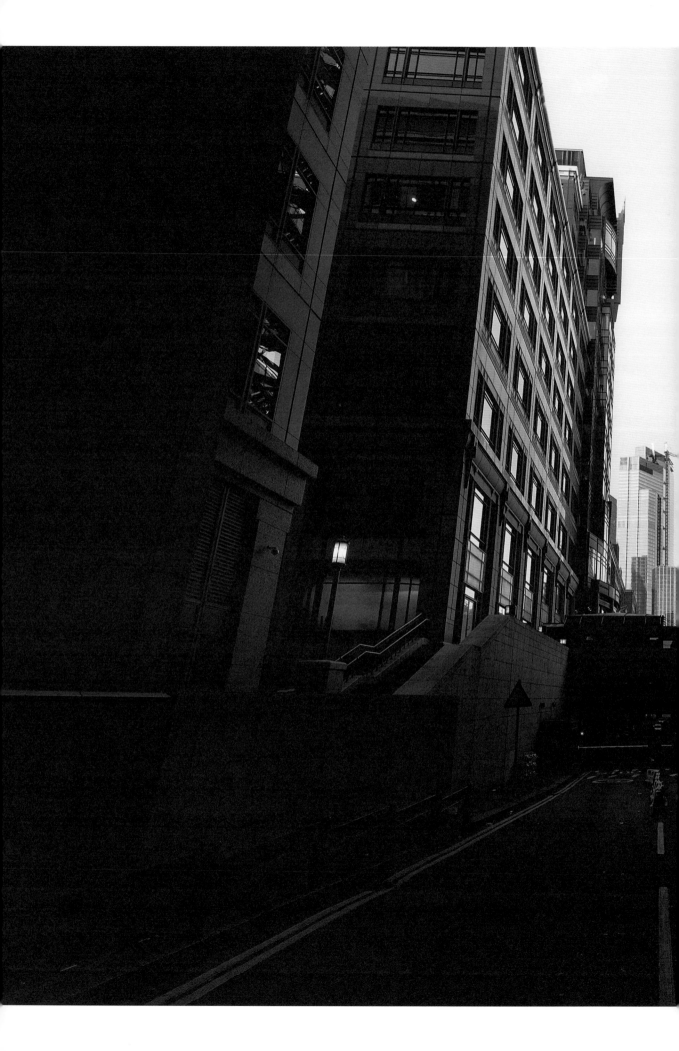

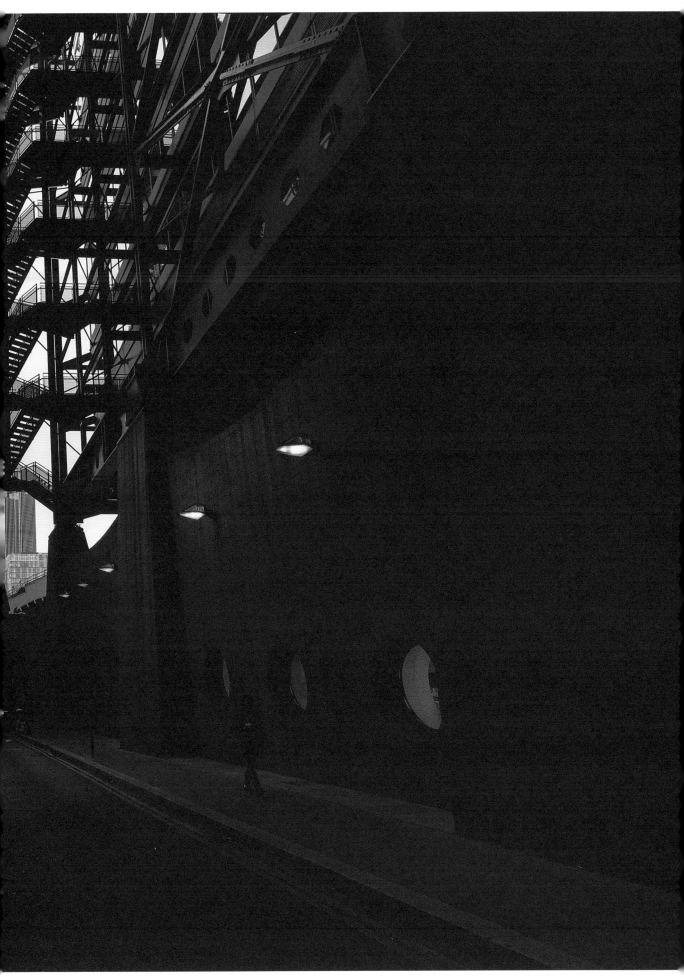

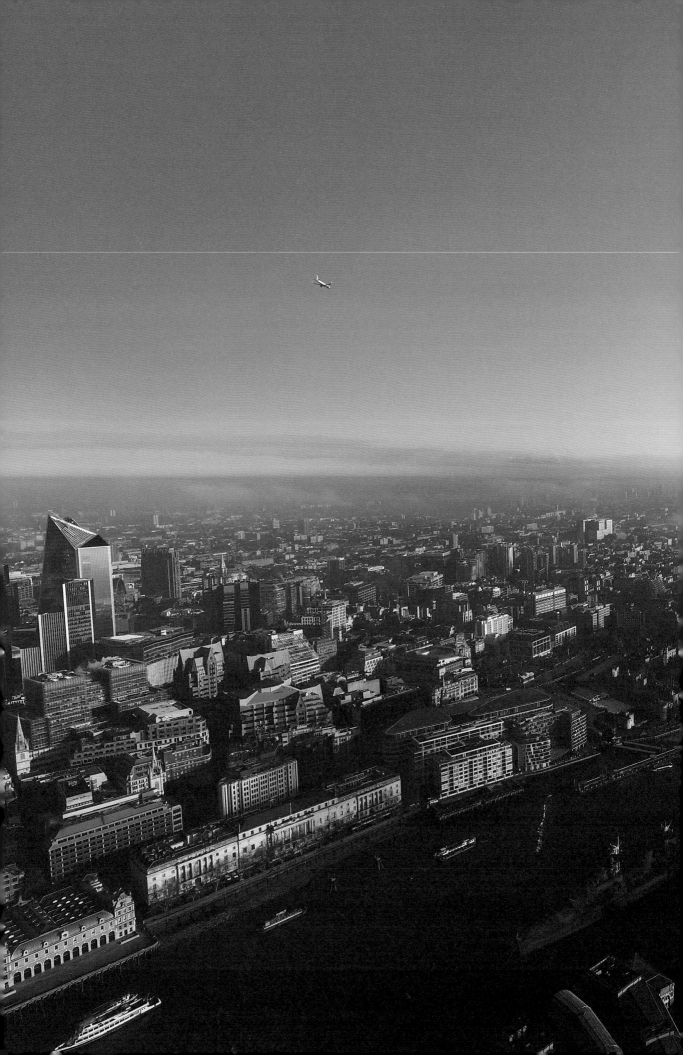

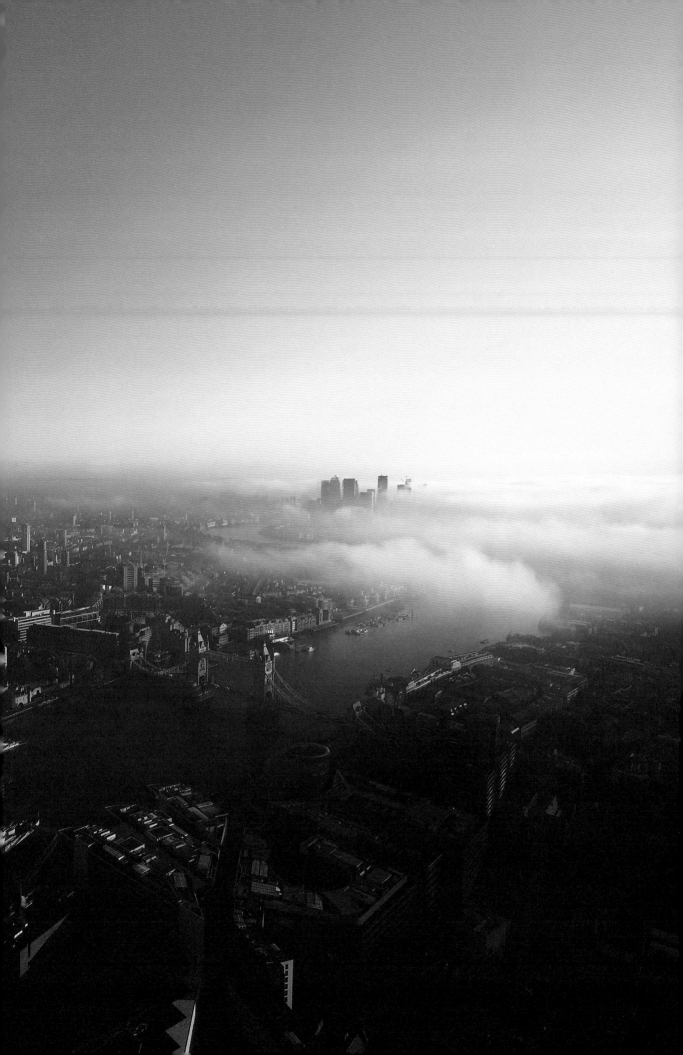

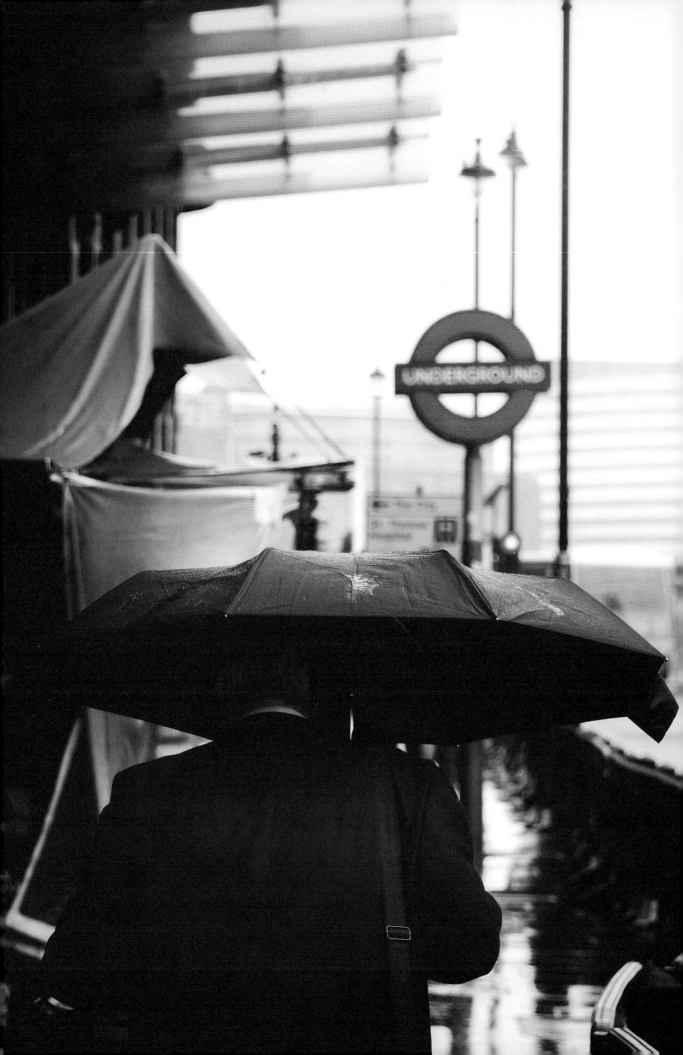

DRIZZLE

PAUL CREE

Some deeper force is at the steering wheel

dodging umbrella tips like hits in kung-fu films

commuters change direction, tourists stop in the stampede

this thing re-positions my feet

hips swing, back swerves, swivel knees

Victoria Street

eight forty-five am

I know the drill

Hood up, nothing special

except I like the drizzle

little drops tap patterns in the top of the jacket's fabric

despite my damp shoulder's proof there's no

truth in 'shower proof,' the clobber looked

sick so I had it

In amongst the masses

all on the office bop

first confirmation of a rain drop, mate, I'm off

Sat on the backstep watching it pour

mums got something on the hob

that sixties brown pot probably mince-meat

nearly-always was

dip bread in the broth

told off

school bus, following the drops carve paths down the window-pane

nursery rhymes about rain

windscreen wipers wipe the day

camping trips barely awake

tucked-up in tents, under rain

in love with the sound it makes

mate

Focus on the feeling

it's all-encompassing

someone said its melancholy or something

no view on the comfort it brings

filters out sights and sounds

bodily essentials run quiet in the background

lost till I wanna' be found

could stay here all day, mate

until god moves the clouds

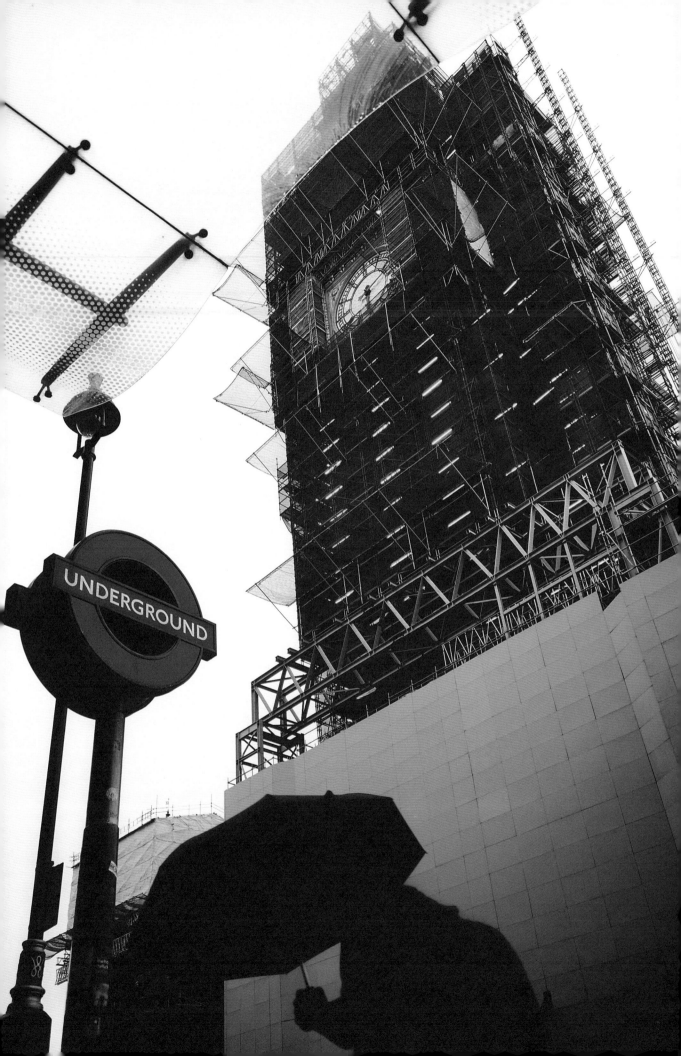

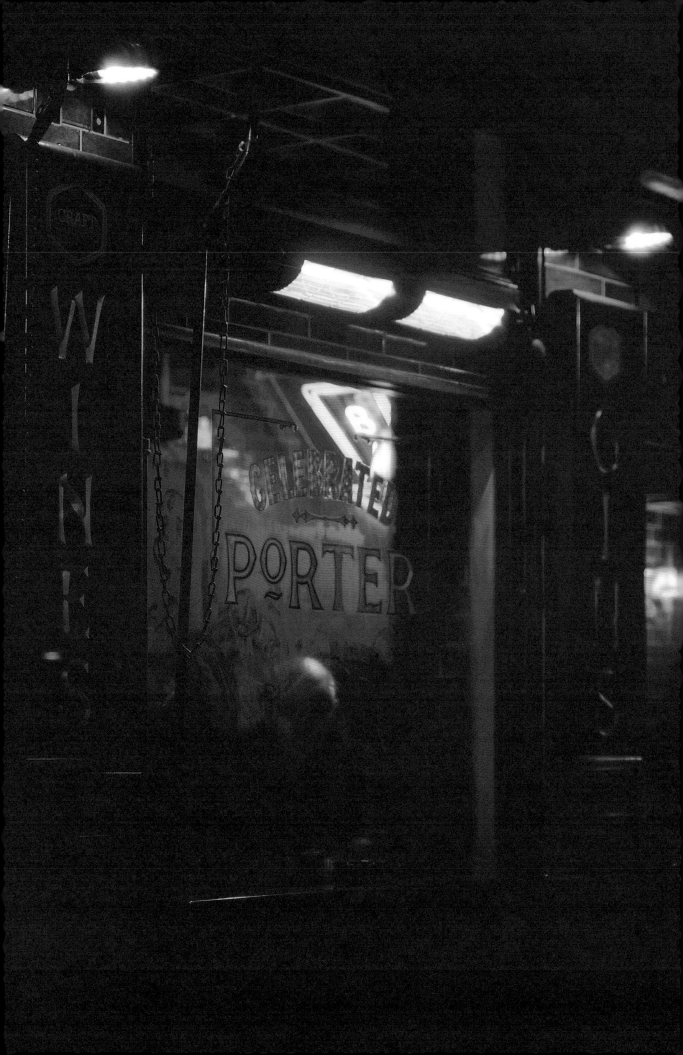

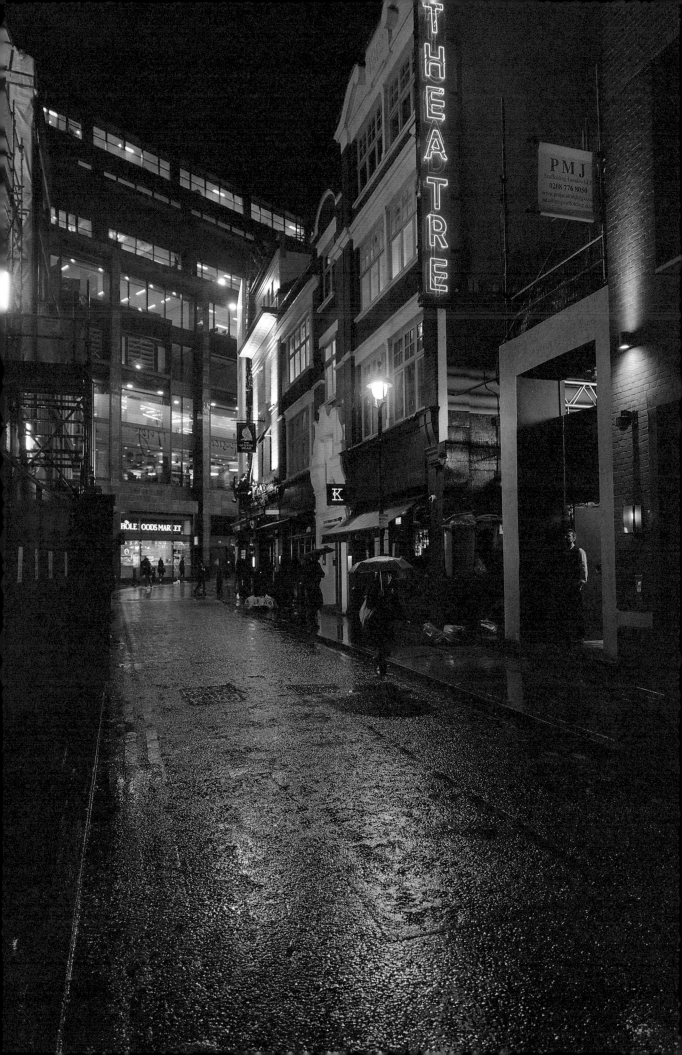

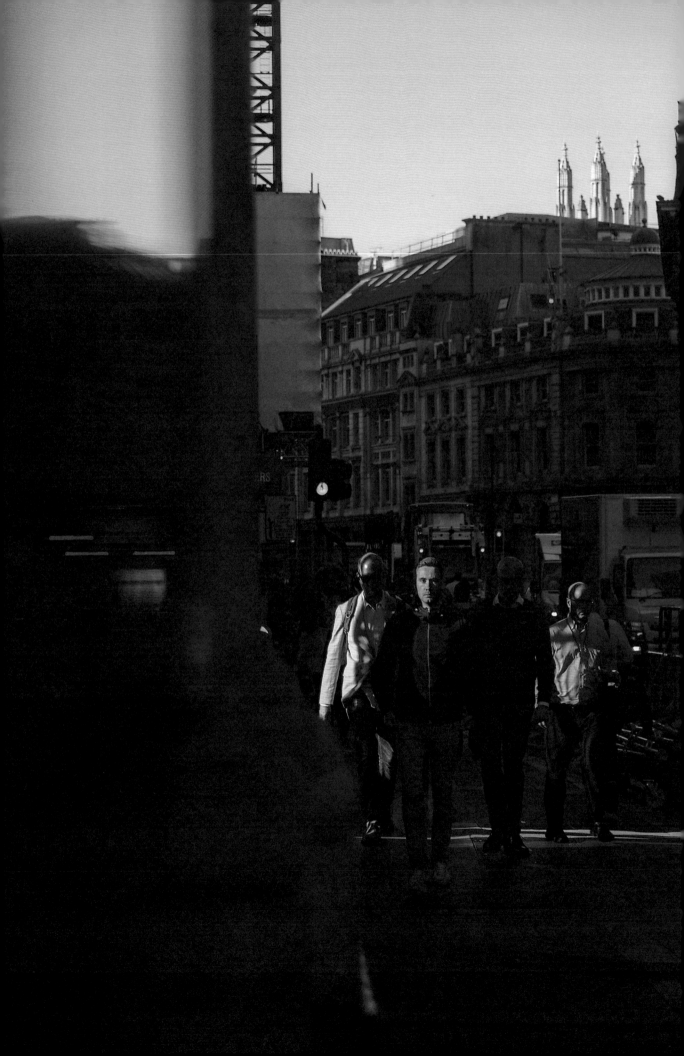

LONDON KINTSUGI

LOUISE McSTRAVICK

London smashed my heart into pieces,

Watched my attempt to piece it together,

Red buses smug as they roll past full,

But my chest is empty.

Glue, the gold from my tears, flows like the Thames for us to float on,

But they ran dry, so I use what's left to put the pieces back together.

This heart as strange as the bed

That now stands in fragments

Waiting outside, alone, for someone to take it.

It wears Clapton Pond lunches and bottomless brunches,

Rooftop strangers who lend ears and kind words to dry tears

That fertilise this London soil with saltwater,

Rubbed into wounds that this city cannot heal.

London is a room with walls that absorbed laughs

That came from a place that no longer exists,

That now mock my attempts to piece this heart back together,

With its memories, imprinted footsteps,

Hungover shops in Sainsbury's Stokey and

Sundays up Church Street, Abney Park Cemetery,

Bagel Shop salt beef.

London you took the air from my lungs,

The song of my words.

Now my vowels speak of you.

You've given me joy in the shape of a man,

No boy, whose hands trace their name on this heart

and do their best to pick these gold thread sutures apart.

London,

You are Walthamstow Marsh Cycles to

Waltham Cross, riding to Richmond blinding rain

Trying not to get lost.

You are getting lost.

You are home on the 149 bus.

You are, don't want to wait for the overground let's get an Uber instead.

You are a night tube shoulder to rest this tired head.

London, you are lonely to a woman who only knew you were big,

Not cruel, until she had to fill her empty chest

With a heart that is no longer the shape it was

Before she left.

———

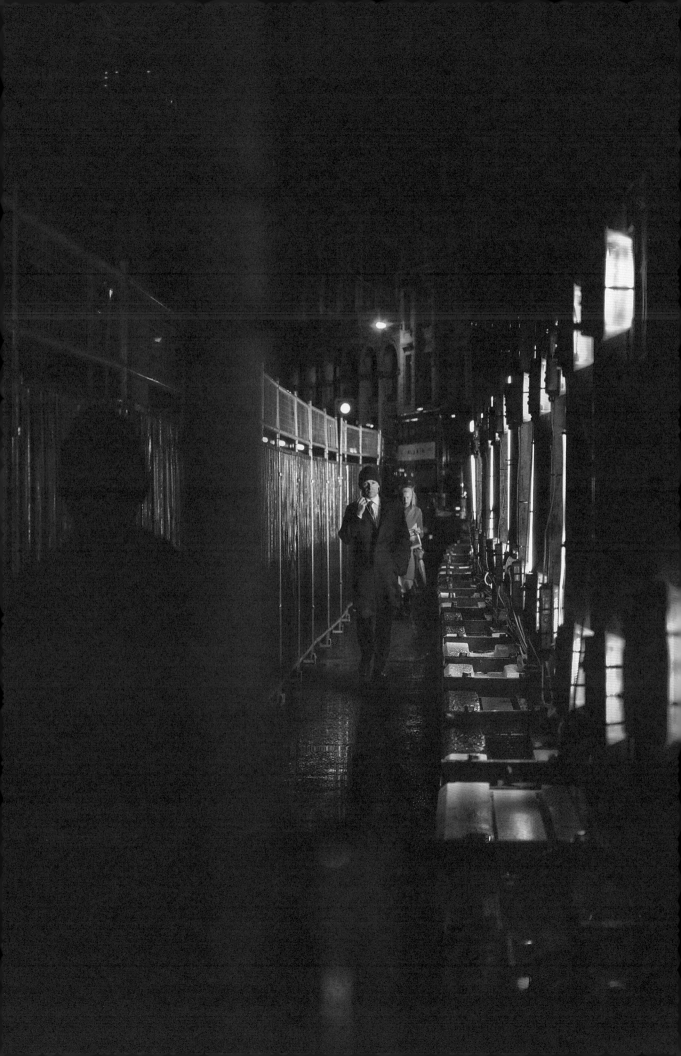

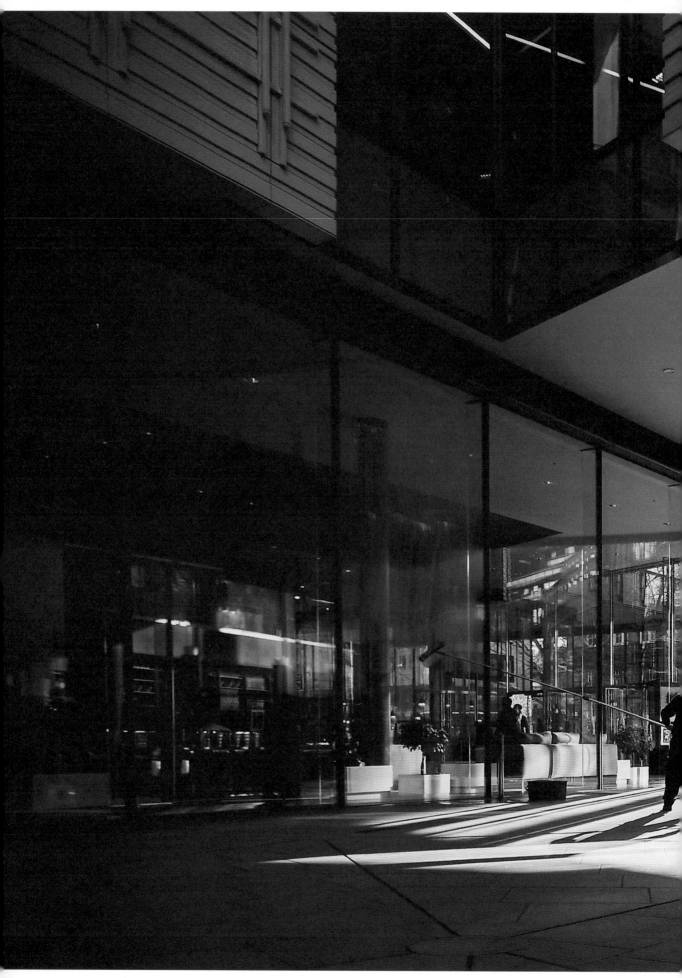

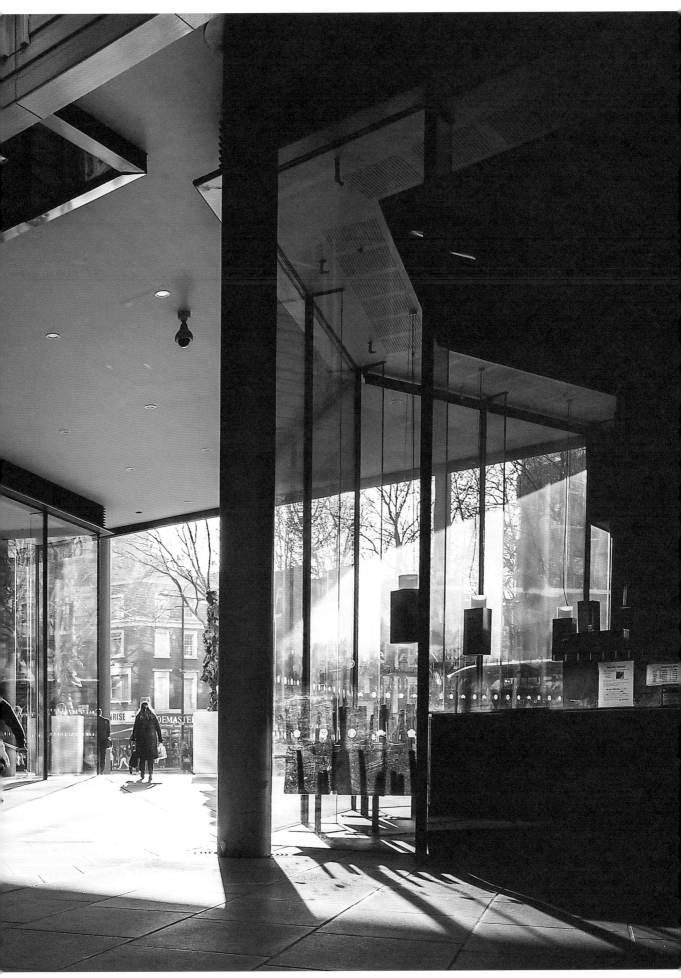

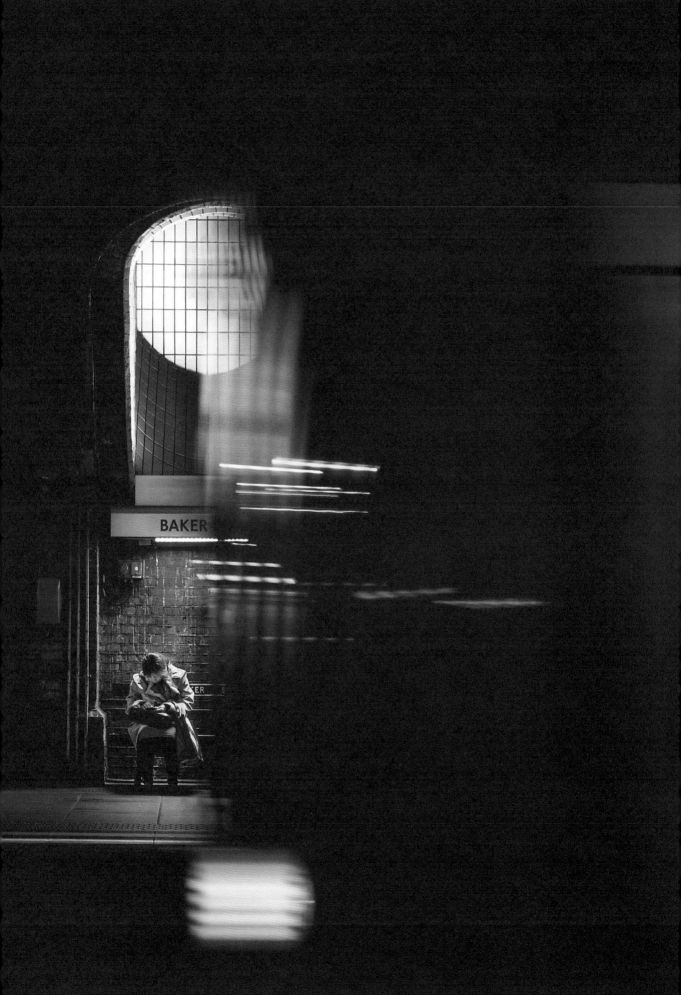

FULL MOON MOMENT

BEN SEE

In those early days we always rode on the top deck.

There was something romantic about sitting at the front of the bus

and looking into people's living rooms.

Stealing a glimpse of someone else's life,

their wallpaper, all character and charm.

Maybe one day we would have a front room full of plants,

a cluttered mantelpiece, curtains with frills, a library to our name.

Would we spend the night sideways on the sofa, buried in books?

Or share a glass of wine in the kitchen while the radio crackles?

We've been on a date. Maybe our fifth or sixth.

Our tummies are tight with Turkish food and cheap beer

and we're heading home. Giddy.

We fall into our favourite seats,

front row as we glide from Camberwell to bed.

The window displays are beaming in the dim. Inviting us in.

A lava lamp, two guitars and an impressive collection of records,

a sofa submerged in cushions, a kitchen sink stacked with dishes,

a bicycle hanging on the wall, a spoilt cat.

And then I see a naked man through the window, brushing his teeth.

You've seen him too. I can see it in your expression.

We laugh with caution and slight embarrassment,

and then with ease and delight. Neither of us quite sure why.

I wonder if he saw us too...

 I wonder if he felt our eyes on his pale skin...

 I wonder if he knows how he broke the spell

 and cemented those formative feelings into something solid...

 I wonder if he still lives there...

 I wonder if he likes being naked...

Oh beautiful anonymous man. You are so important.

We still ride on the top deck of the bus

catching flashes of people's private lives.

Ever in hope of another milestone moment.

———

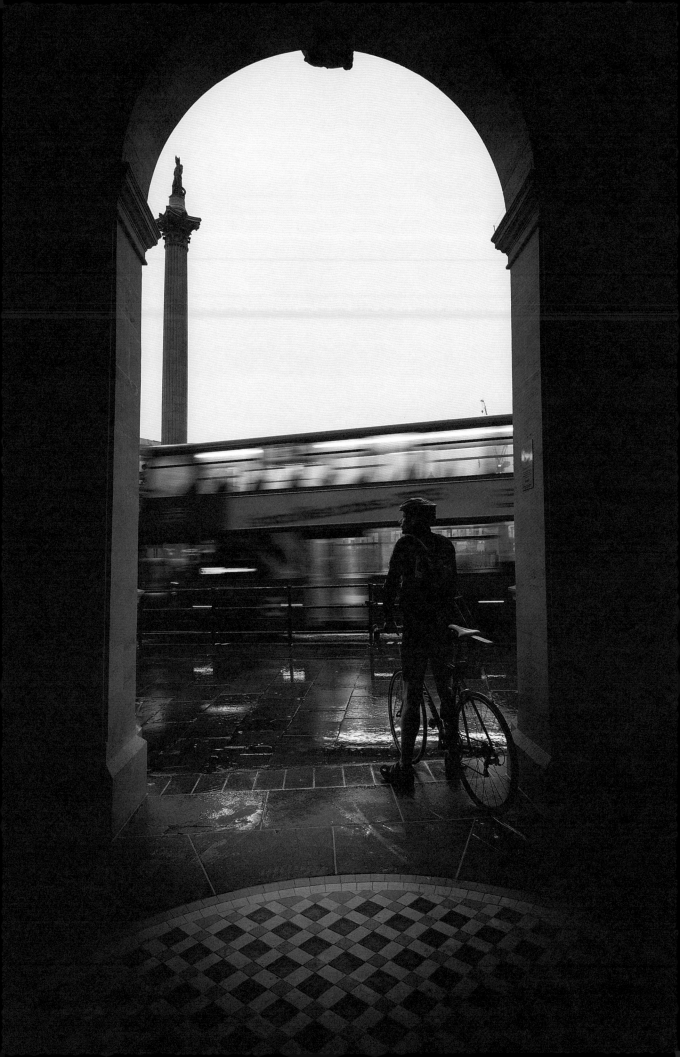

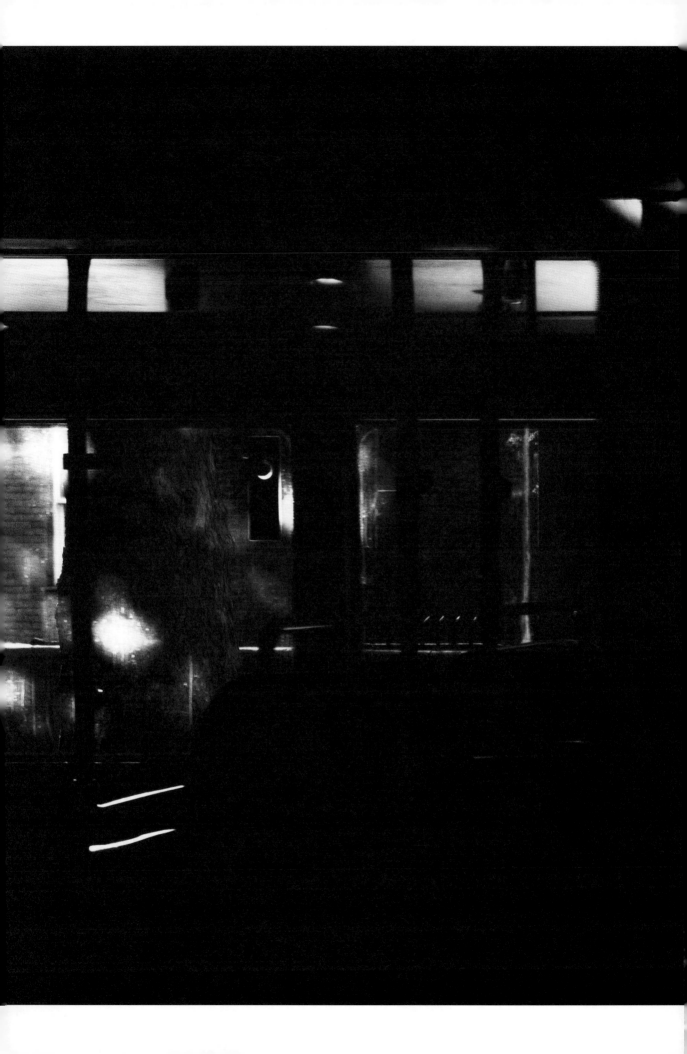

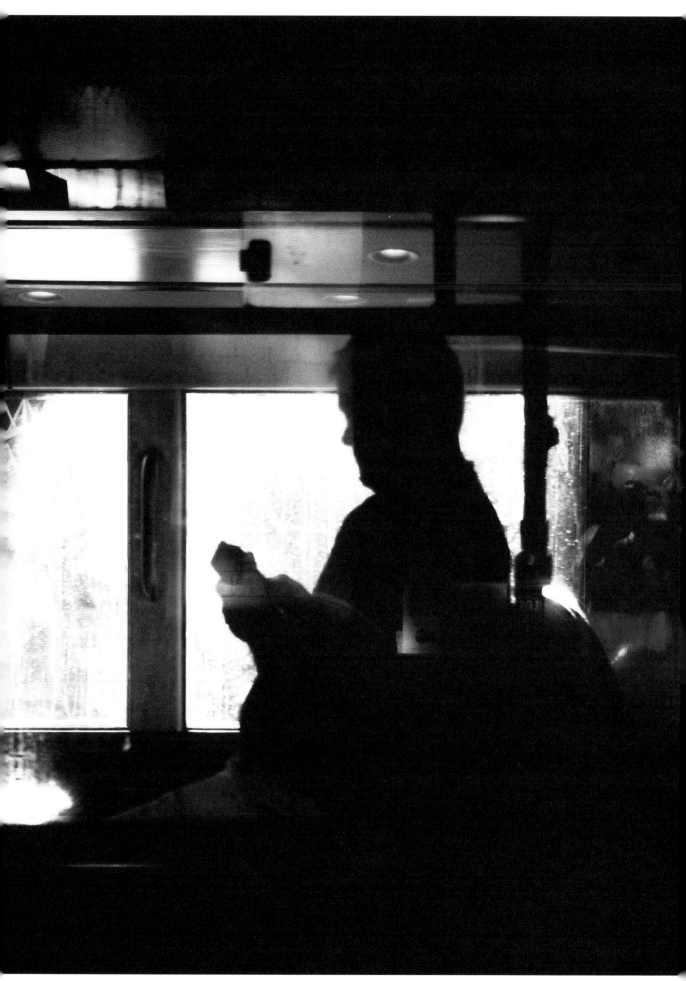

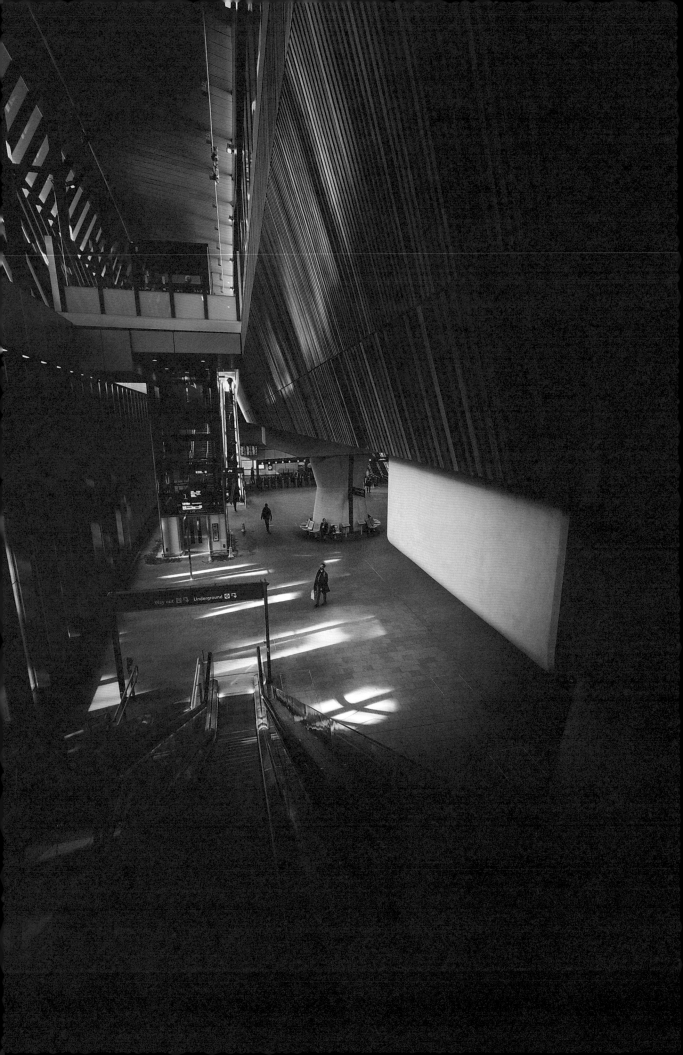

THE PENNY DROPS

CAROLINE DRUITT

Ears devouring headphones,

sounds to block out interactions,

eyes down,

constant frown,

the lines etched vigorously onto faces.

Everyone is on their way to different places.

Fingers consume iPhones,

as if the answer to all life's problems

lay there, like secrets,

behind the seductive, luminescent glare.

'Please stand back behind the closing doors'.

Bare bloodied feet shuffle on silently from the platform,

covered in debris from London's city floors and its constant human storm.

Dejected.

A few stray eyes turn their gaze, and let them linger,

unaffected.

Topshop bags litter the gangway,

as your trembling voice plucks up all courage just to say,

'I'm so sorry to disturb, I have to confess, I got into some trouble and now

I'm homeless, just wondered if maybe you could spare me a little change',

someone rolls their eyes and groans within your hearing range.

Staring you down as if you are audacious or otherwise deranged.

'I'd be so grateful for a hot meal and maybe a bed in a hostel tonight',

tumbleweed blows through the carriage as everyone tries to pretend you're not there,

with all their might.

Suddenly more interested by phones and shoes and locks of hair,

your tired battered body gives their groomed ones a fright.

Purses stay tight.

Sometimes out of pure spite,

something doesn't feel right.

'This train will terminate at Aldgate East'.

You think your life might terminate before they reach their destination.

It's too late.

People have the power to debilitate, discriminate, humiliate, alienate,

before they've even reached the next station.

The tube doors slide slowly open,

you disembark, more broken.

The train stops.

The penny drops.

———

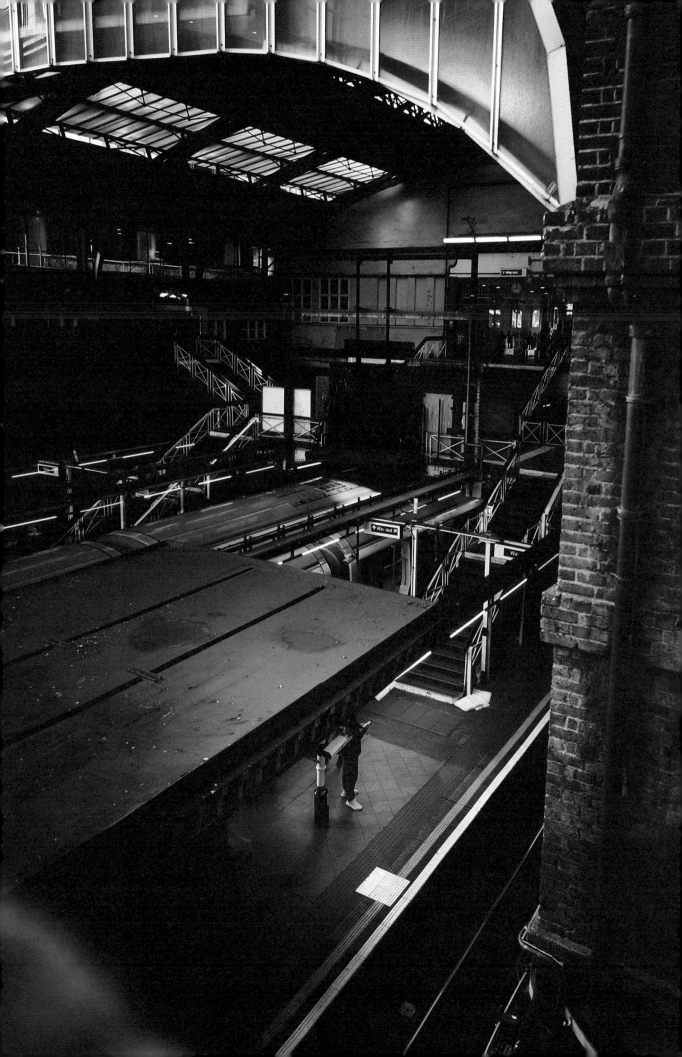

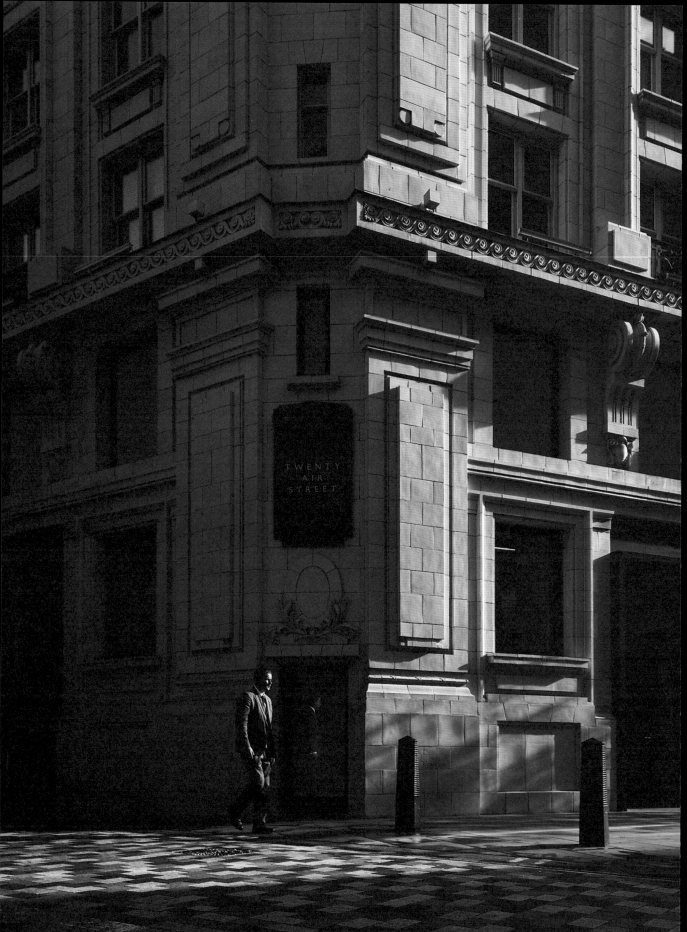

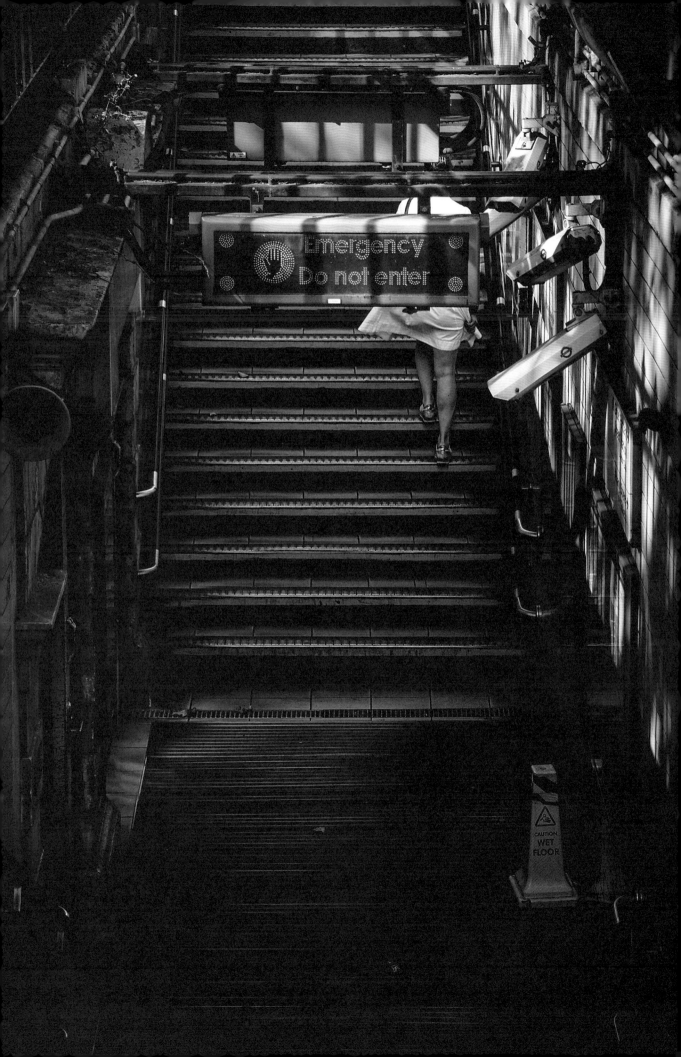

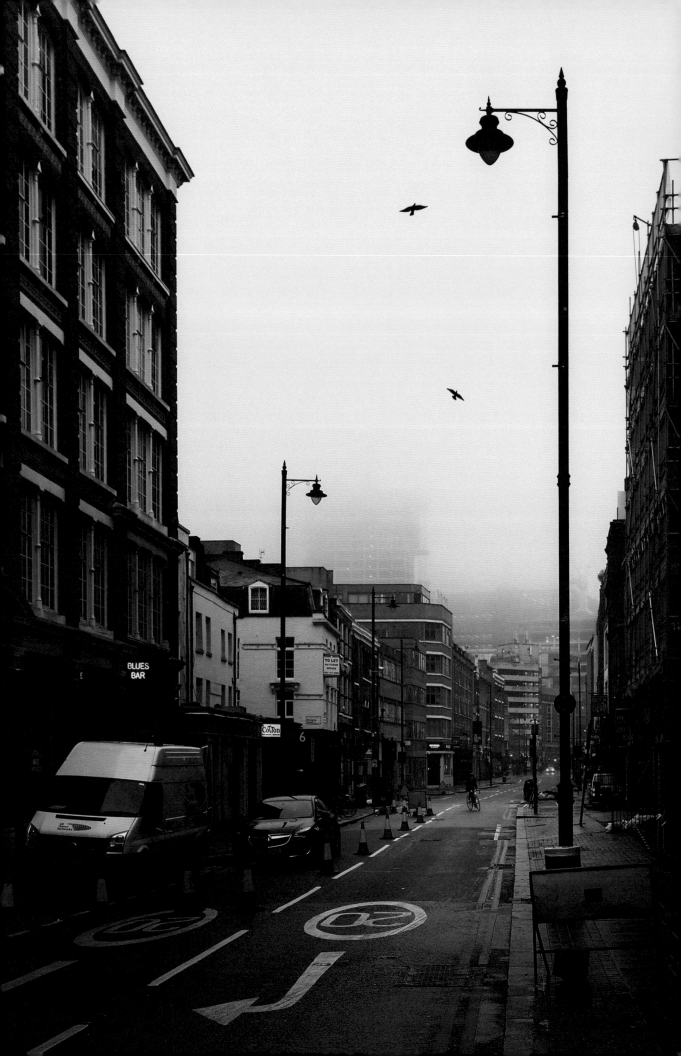

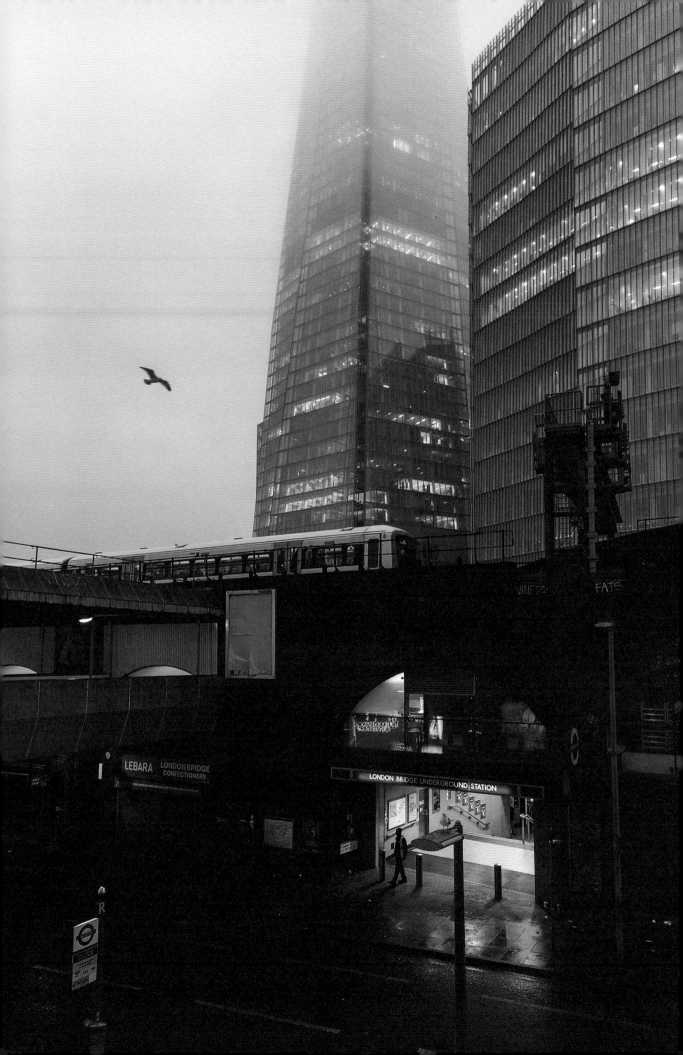

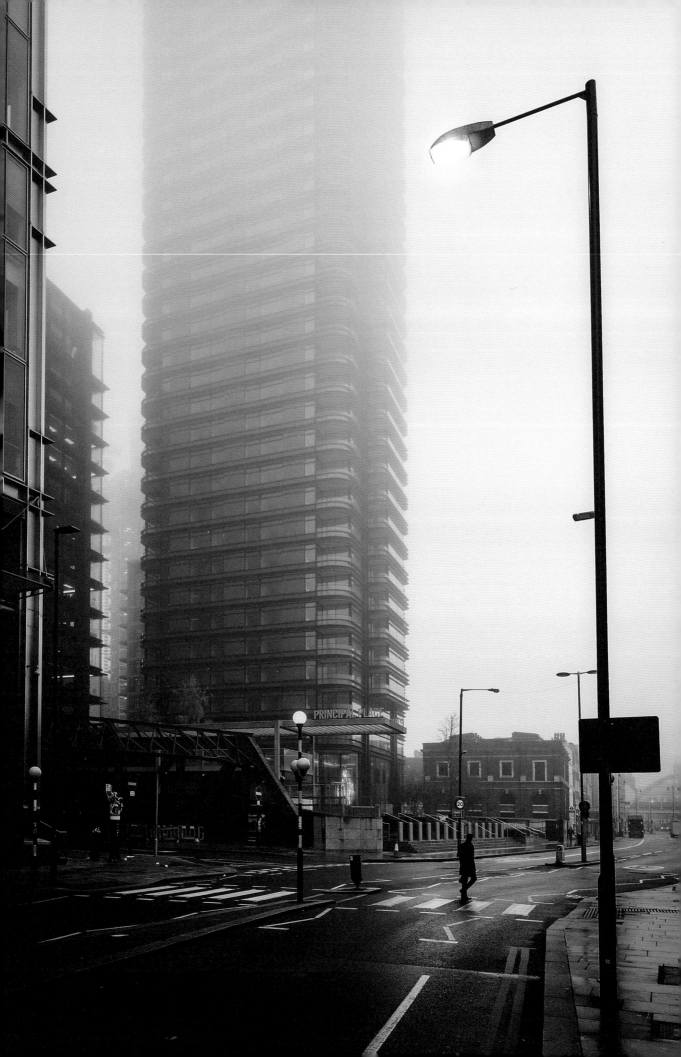

TOWER BLOCK LIFE / LIVING IN BOXES

SHEZ CHUNG BLAKE

I yearn to break free from the walls that contain

Piled high

Boxes

Curtains feign privacy

But we see right in

Cheap paper lamp shades

Light the way

Boxes

Stacked up high

Tiny windows offer snapshots

Of faded hopes and dreams

Splattered on bad wallpaper

Which betrays a lack of taste

Or wealth

And opportunity

Boxes

Piled high

Prison cells

Caged birds

But we make those boxes home

Learn how to sing

Melodies and lullabies

To soothe the children

And our fears

Make us forget we are trapped

Wings are clipped

Living life via digital screens

Boxes

Filtered pain

Boxes

I want to break free

———

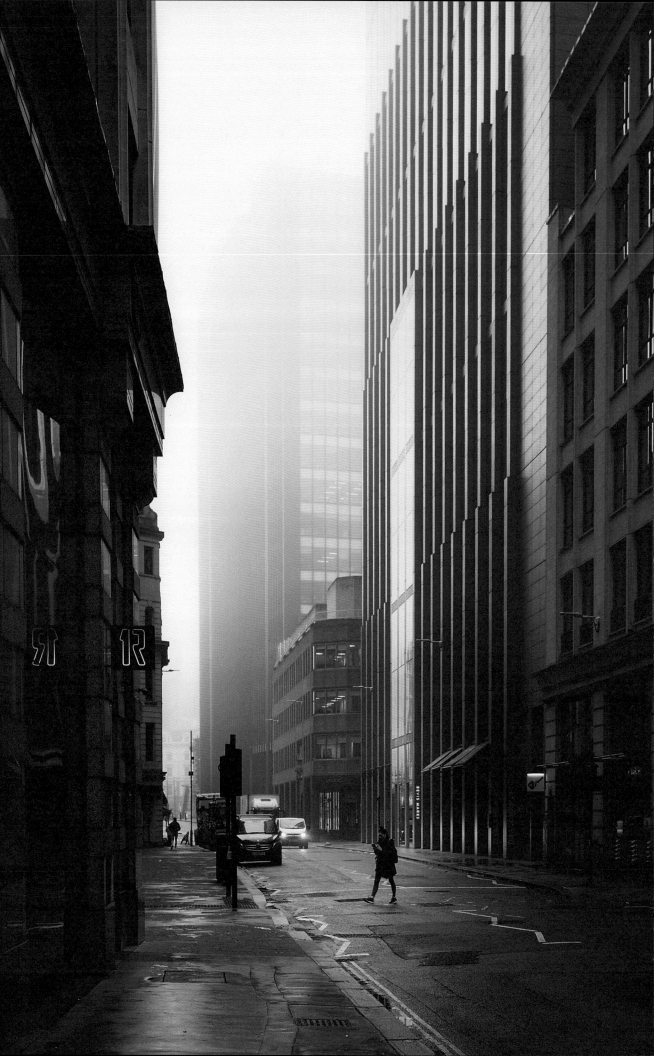

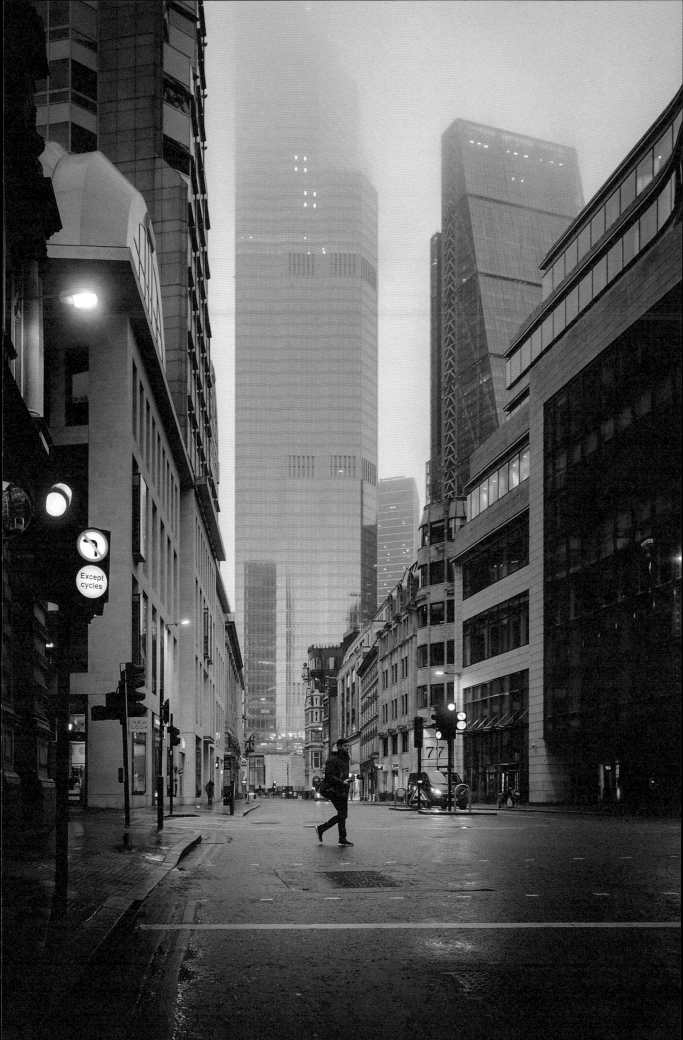

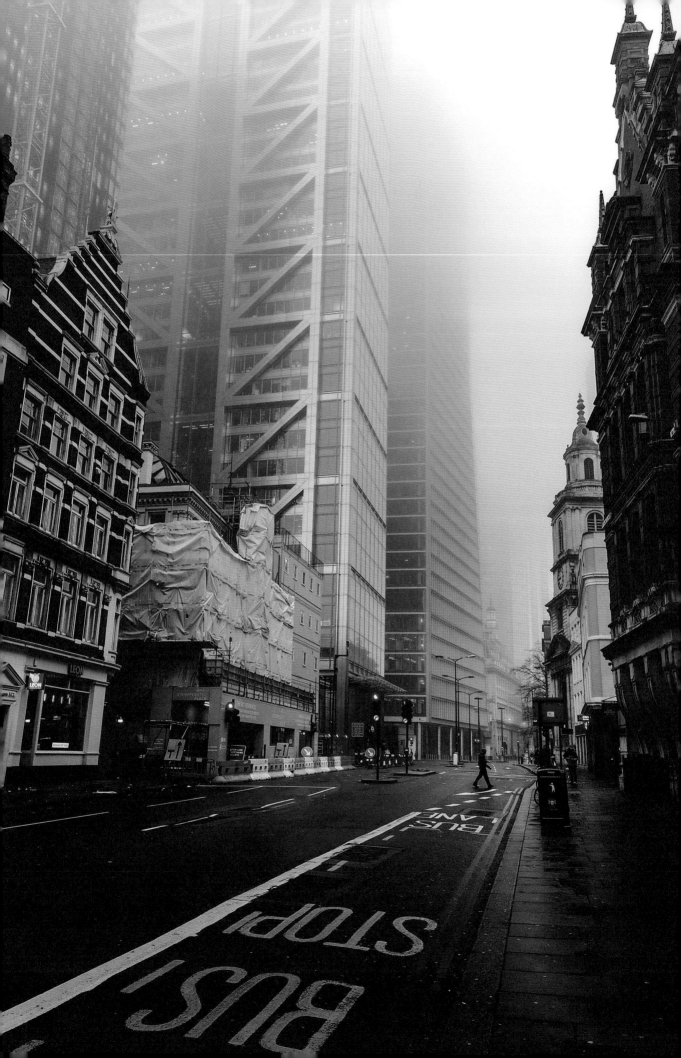

THEY BAN-SHE

SAM EL-BAHJA

Don't let her scream.

Don't let her shout.

Don't give her any reason to come about.

Don't let her become part of your deepest doubts.

Just keep her calm, keep her unalarmed.

But if she ever was to be awakened from her slumber,

You better be sure to take cover.

As she slowly hovers awake,

Showering her blue and red colours all over the place.

The worried parents of London call her upon,

And as soon as you know it you'll hear her shouting,

She is screaming over your pain.

I don't know whether to call her cry a reassuring sound or a painful one,

Her call represents the death of so many and possibly the saving of some.

The sound of her siren seems too common in my area,

Drowning out every sound of happiness.

As she passes eyes dart in her direction,

Attention targets the banshee of London.

A moment of silence surfaces,

As if someone has already died.

She shrieks some more.

And I just wonder, whether I should be happy that lives are being saved,

Or is it the opposite?

Is it that her cries are just a façade?

Trying to hide the real reason behind her uncanny cries,

The unholy howl that needs to be exercised,

And begotten of

She needs to be replaced with a happy sound,

With connotations of salvation not disappointment,

So I say once again,

Don't be a reason for her to come about,

Don't let her scream

Don't let her shout

Let her rest.

Let her change.

———

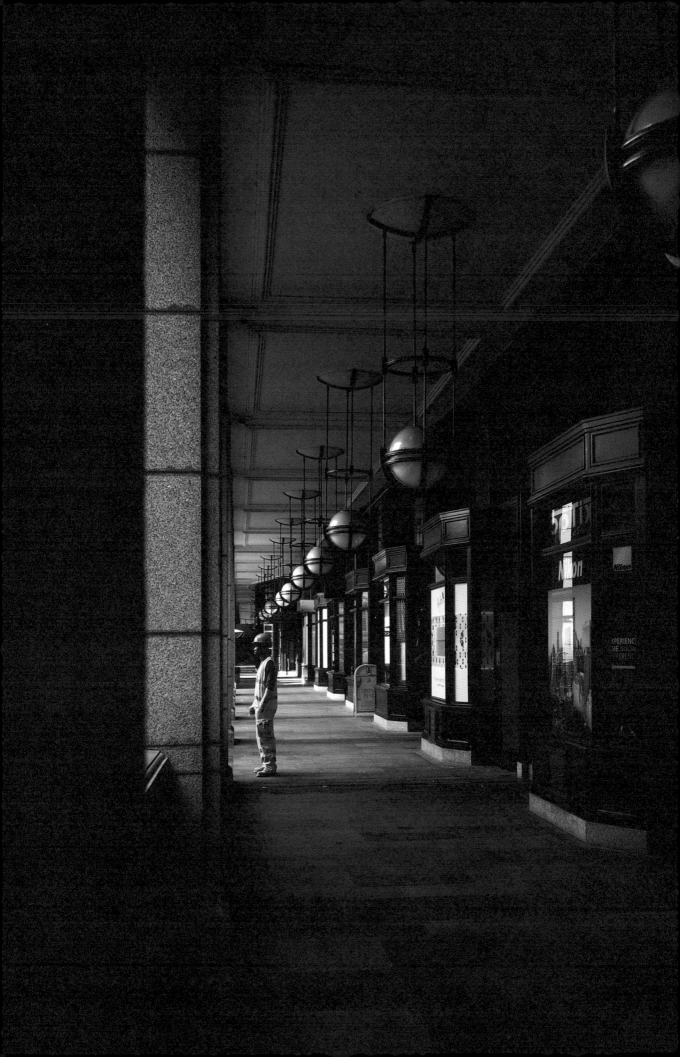

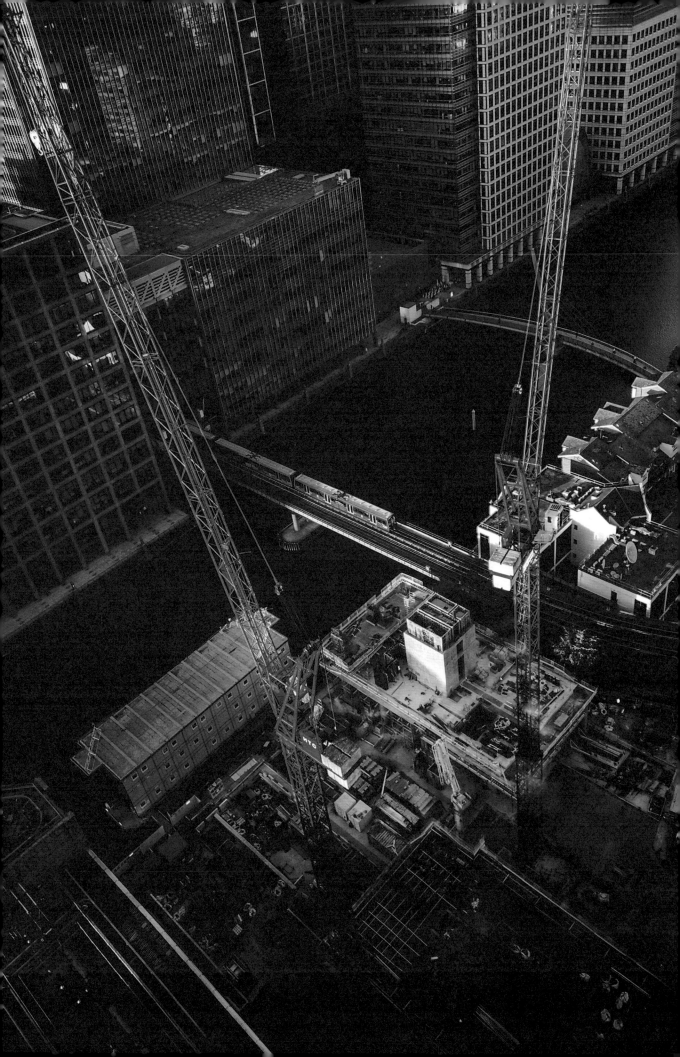

CRANES~

ASTRA PAPACHRISTODOULOU

cranework,

cranework bend

lift – they mend

close to proximity

building nests

———

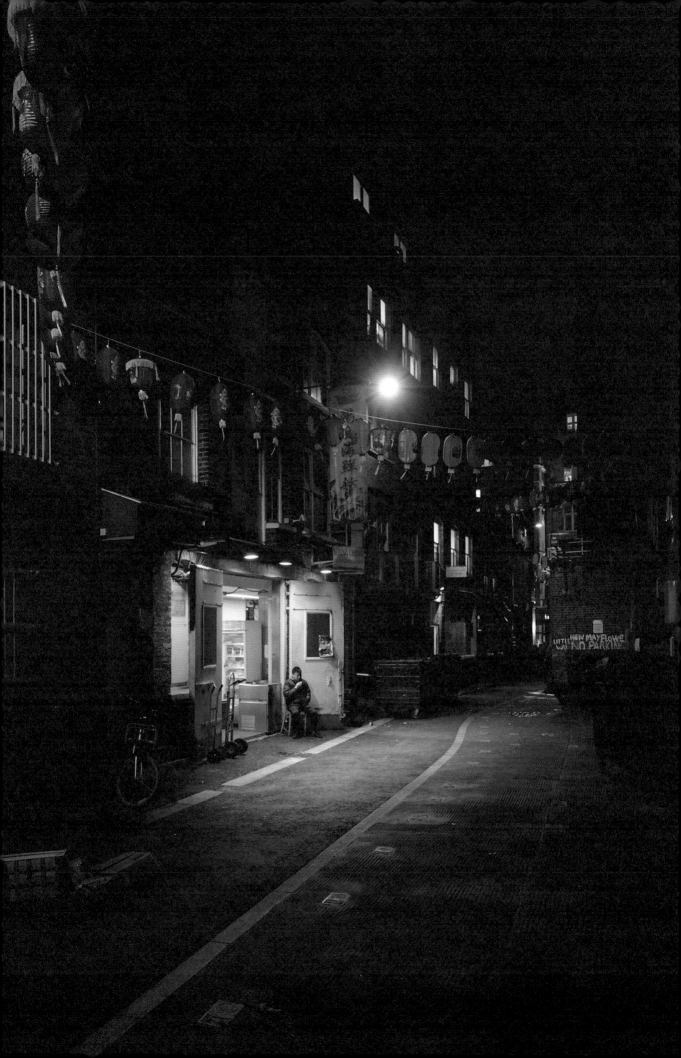

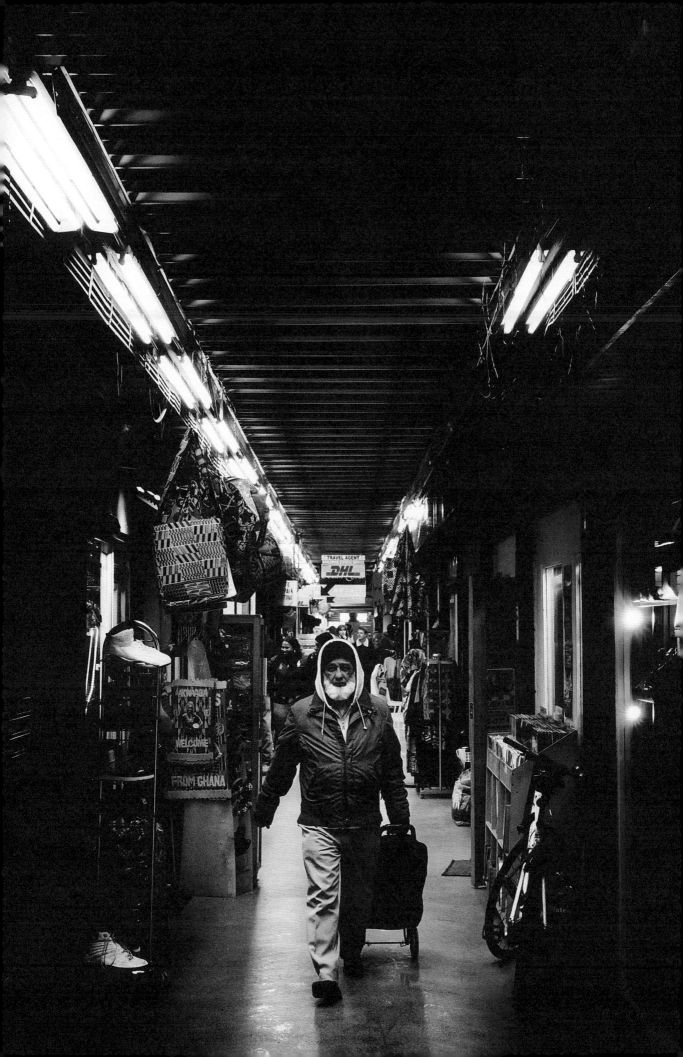

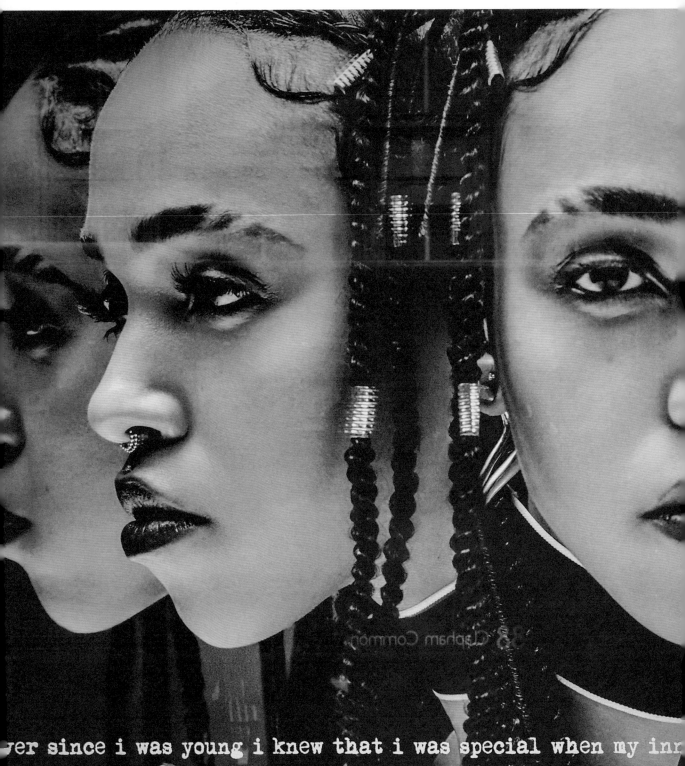

ver since i was young i knew that i was special when my inn
ached to succeed, to heal, to make a difference in the worl
frequency i recognize within myself. i hear my voice, i
we do not compromise. not today. not tomorro

FKA

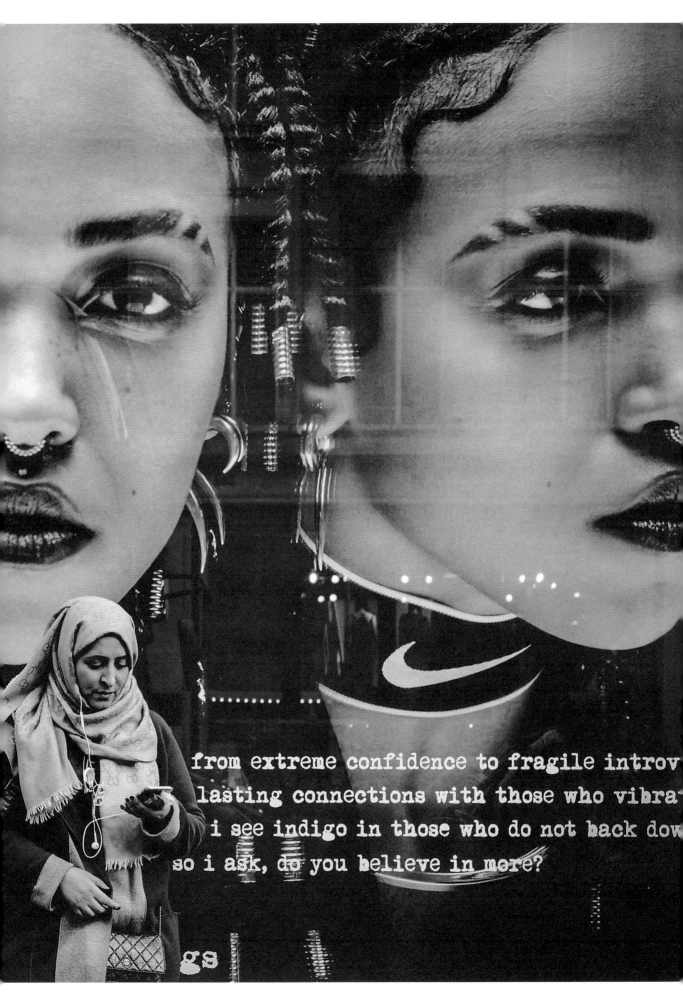

from extreme confidence to fragile introv
lasting connections with those who vibra
i see indigo in those who do not back dow
so i ask, do you believe in more?

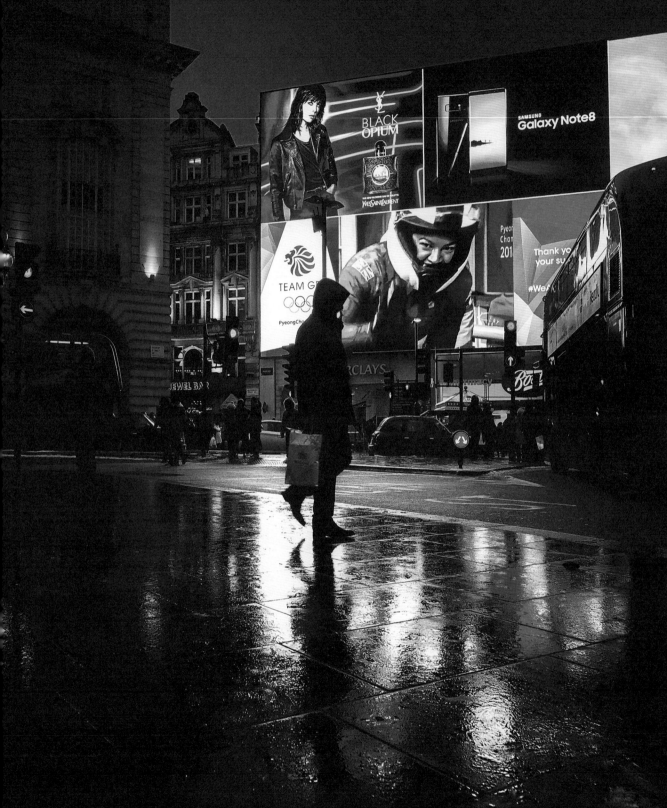

LONDON'S DISPOSABLE CAMERA – FILM II
DANNY MARTIN

Revolution upon the city but let's get to the nitty gritty. Right vs left. Corbynistas. Boris believers. Supposed Snowflakes ordering skinny lattes. Every second shop nowadays is a quirky un-corporate corporate barista's. Everyone knows a geezer who knows a geezer that can sell you discounted items from fridge freezers to Filas, the manor littered with Sunday market schemers. London's skyline will take you to the cleaners. I love this city. Old London. New Scotland Yard. Skyline dreaming of valentines believing you're being taken up the Shard. Hearts of glass. Towers of Gherkins. Green littered bins filled with the McDonald's versions. Oxford Circus. The outside the night club lurkers. The virgins. The committed. The in-a-relationship-but-have-a-flirt-ers. The players. High stakers. Casino roulette & blackjack gamers. We pay homage to the drunken nightclub bathroom strangers. Hangovers. Hang-on-ers. Lamb doners or vegan sausage rock and rollers. The £8.83 for a cup of coffee but still asking in smoking areas for Rizla papers. Rolled tobacco and tobacco docks. The roll back and forward of the Big Ben clock. River Thames cuts through. Cut loose on rooftop bars. Uber's undercutting black cab drivers. Congestion charge. ULEZ. A night in this place grabs you by the... Soho saunas and a Chinese in Chinatown. China whites will be the death of you. Shoreditch. Re-mortgage to afford it. We live up and down like the exchange rate. Alleyways cohabited by vomiting drunken states. But that's a standard London night – we wouldn't have it any other way. I love this city.

———

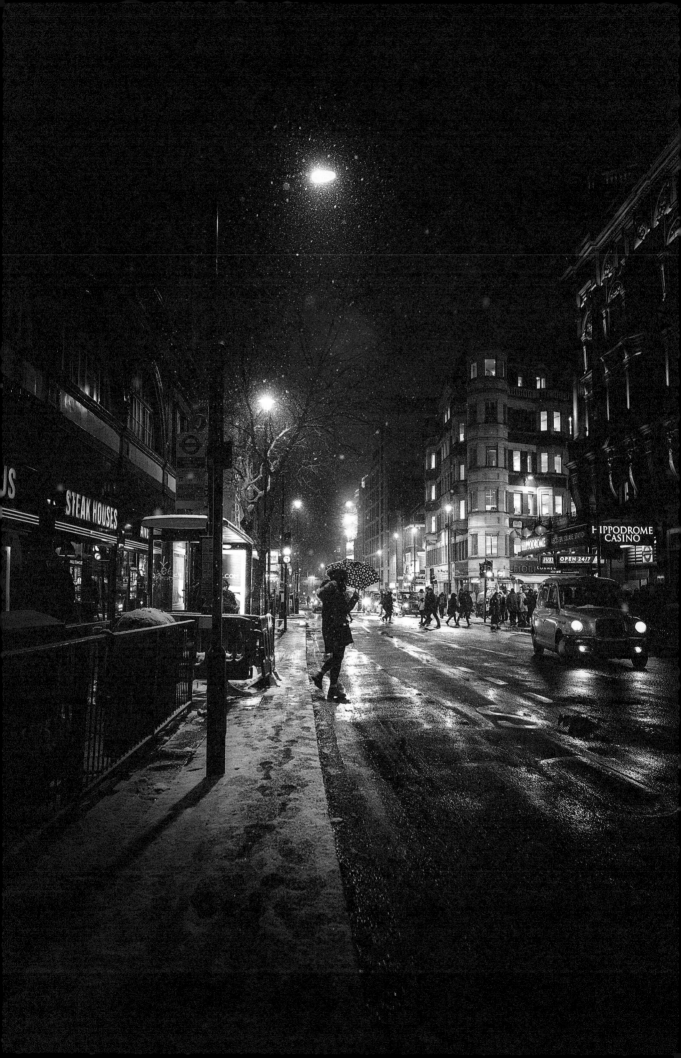

METAMORPHOSES II

ASTRA PAPACHRISTODOULOU

moving snow people

caught in city lights

moment to moment

streets caught in snow

rage of moving lights

moondrifts the city

moonshines the rain

concrete snow-drifts

creating momentum

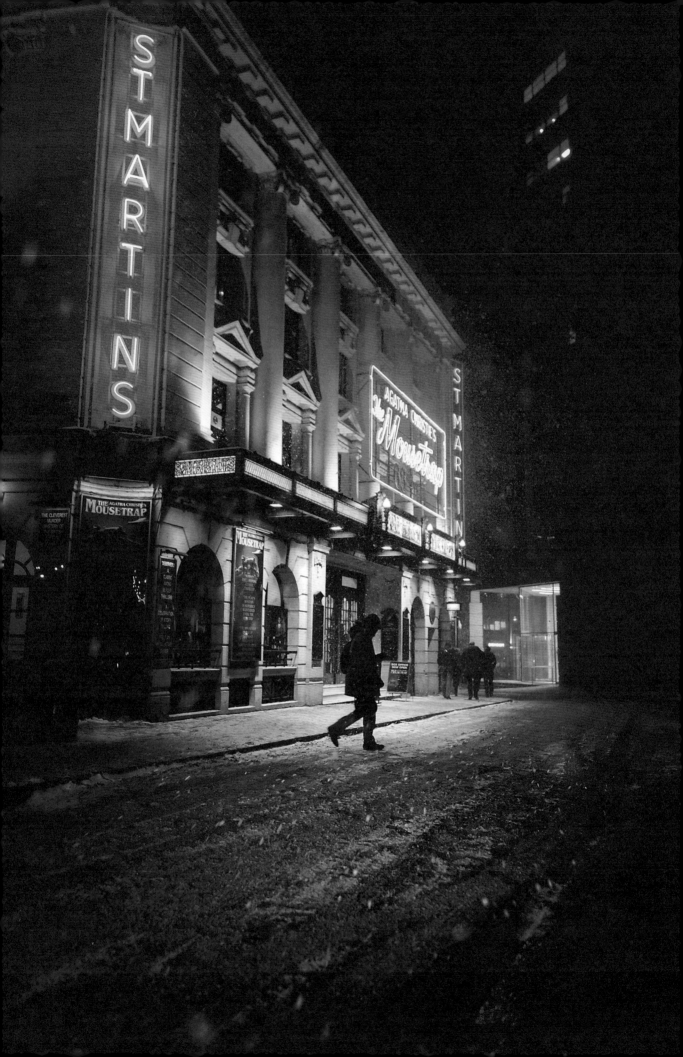

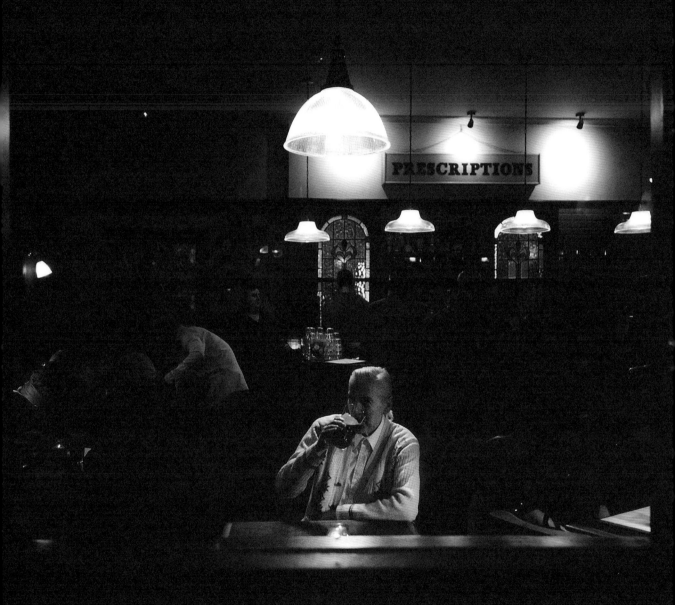

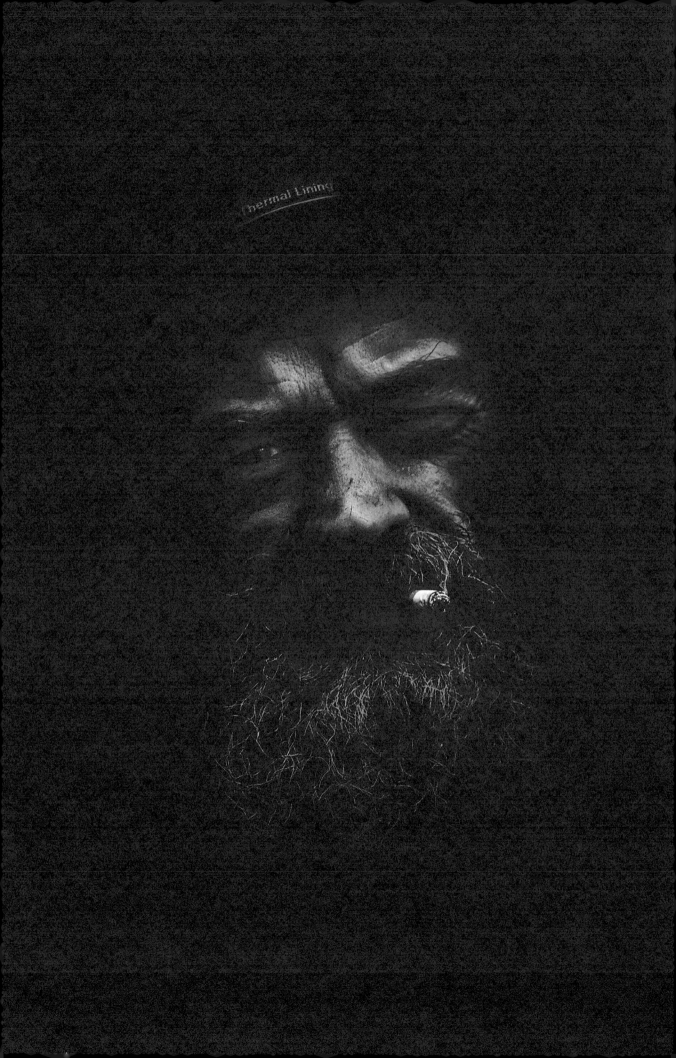

SEARCHING

TOM GILL

Said he was soul searching.

Was living off the dole,
Now he's sleeping in the cold
Searching.

Times are hard,
But he's trying hard, not to moan
Burdened.

Running from big issues,
Denting a hole in his soul
Hurting.

Selling Big Issues,
In his shoes, with no soles
Searching.

Said he was old,
Whereas I was young and bold

"Make sure you grab hold of the ones you love son, and keep them close"

So I told him, I was soul searching.

Was living on my own
Working
9 til 5, just to buy the latest phone
Searching
For a connection from the bedroom in my home
Flirting
Through an app.

Got all these matches
But thinking of an old flame,
Means I still feel alone
Certain
I don't wanna get up when I close
Curtain

He said "when you lose everything
You realise what means the most"
I heard him
Learning
How to cope
Gurning
Every Friday night just to escape the whole world and...

Maybe all we needed was that little bit of love?

So we hugged

And he stunk.

But I think we were both in need of that touch.

And for another man
To see behind the cans in our hands
And look into our soul

Searching.

———

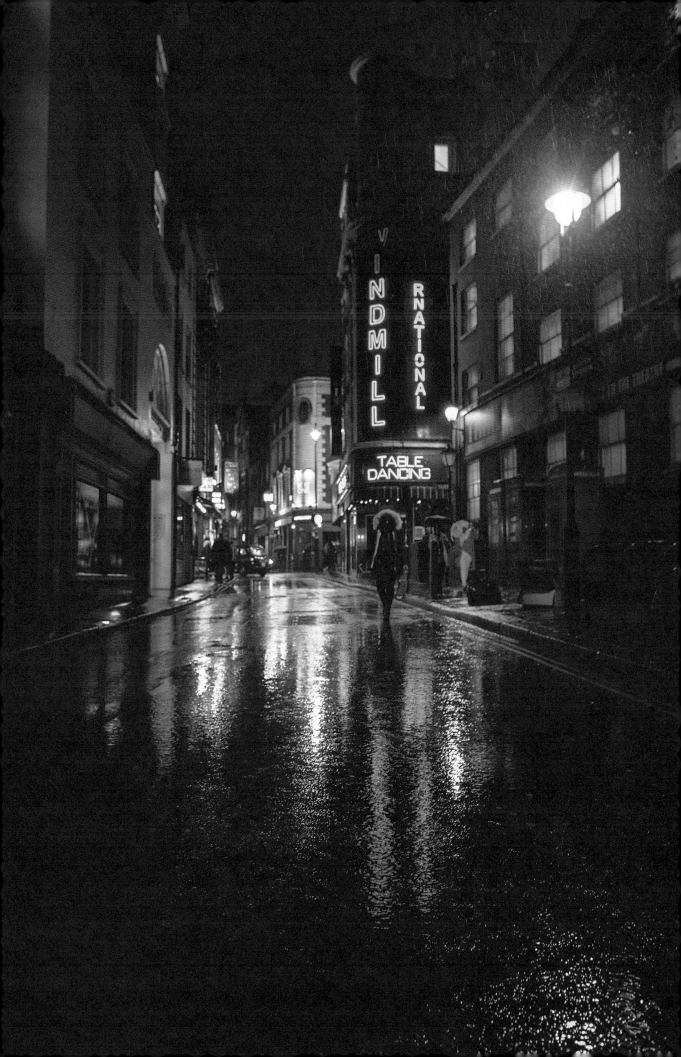

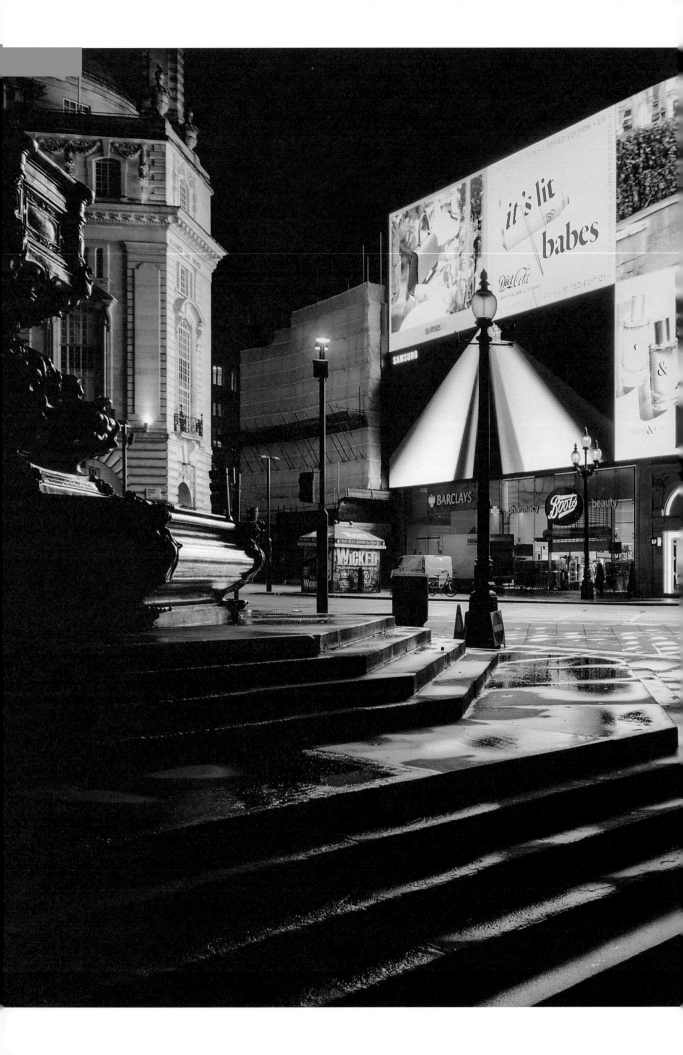

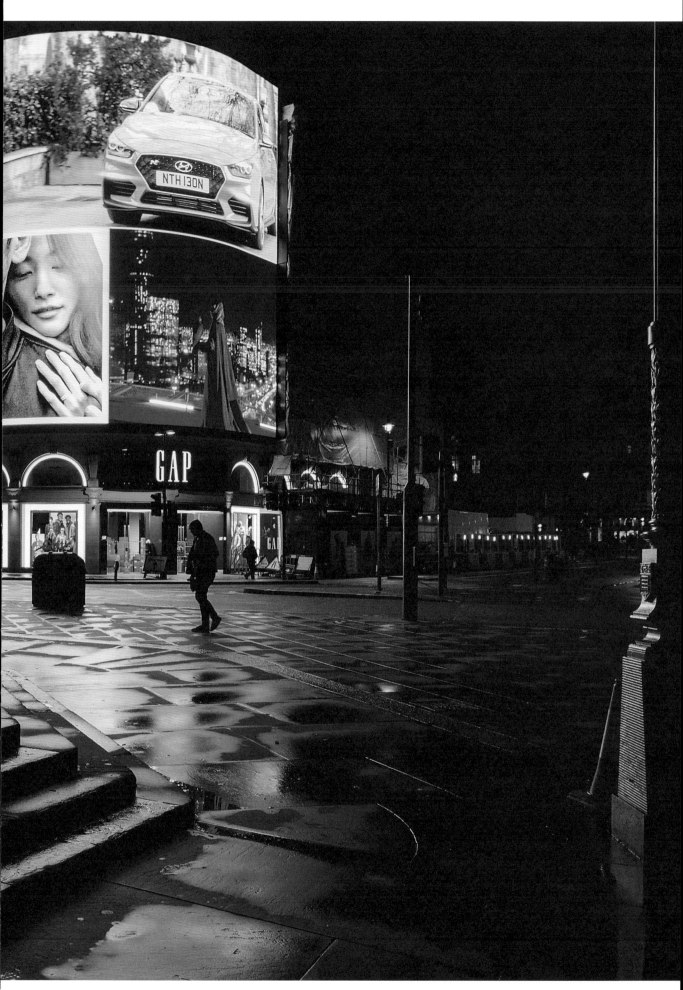

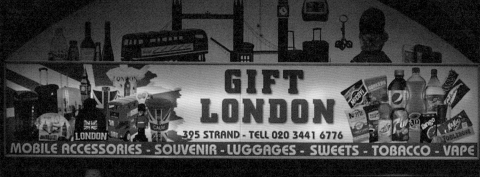

GIFT LONDON

395 STRAND - TELL 020 3441 6776

MOBILE ACCESSORIES - SOUVENIR - LUGGAGES - SWEETS - TOBACCO - VAPE

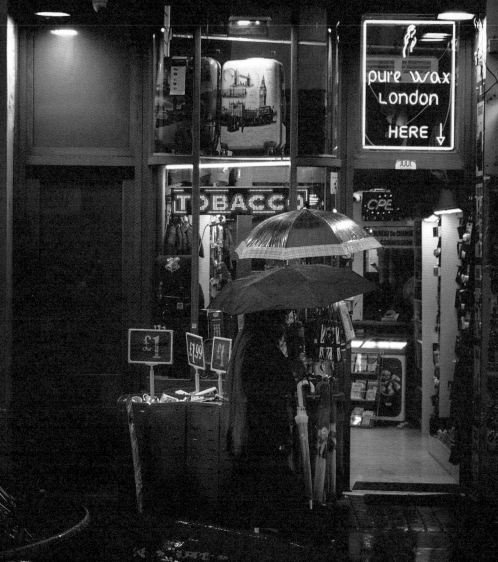

BIRTHDAY BOYS & BIRTHDAY GIRLS
JANAY STEPHENSON

Its 5am and I'm walking home with a stranger whom I'll soon call a friend

I'm told to talk and mingle with different types of people but I don't have much to say other than

Hi, I'm Jai.

I've kissed so many cheeks tonight.

Flirted with so many uninterested women tonight.

Rode in so many Ubers I didn't pay for tonight.

Went along with every next move made for the night while pretending to be interested in plans

made for tomorrow

I took a walk on my own to a park around the corner and fell asleep on a bench. Made my way

back about half an hour later to a crowd that seemed unfazed by my arrival so probably hadn't

noticed that I had left

Yes, it is better to be a fly on the wall than a wallflower because at least the fly can fly away.

But I am on my way to the next venue without the person I came with to the first. No one seems

to know whose house this is but I manage to find the bathroom on my own

There's a comfortable chair here so I sit and decide to enjoy the show. A few conversations I

might remember later and a few one liners I might turn into a poem

Thank you to the ones who made sure the new girl didn't get left behind, next time the Uber

will be on me.

It won't be. I never know where we're going

I never know who I'm talking to but he's just said his birthday is tomorrow and she's just blown out 21 or 24 candles

Happy Birthday. I guess this whole night is for you

My first London night came in a drunken haze but thank God for my ex's jacket that kept me warm as night turned into day

You've got a lovely voice and lovely eyes too. You know where I live better than I do, you walk me home even though I tell you you don't have to. My building's just there, I don't have your number but maybe I'll text you.

I lay down in bed I close my eyes too

I know tomorrow is coming even though I don't want it to

———

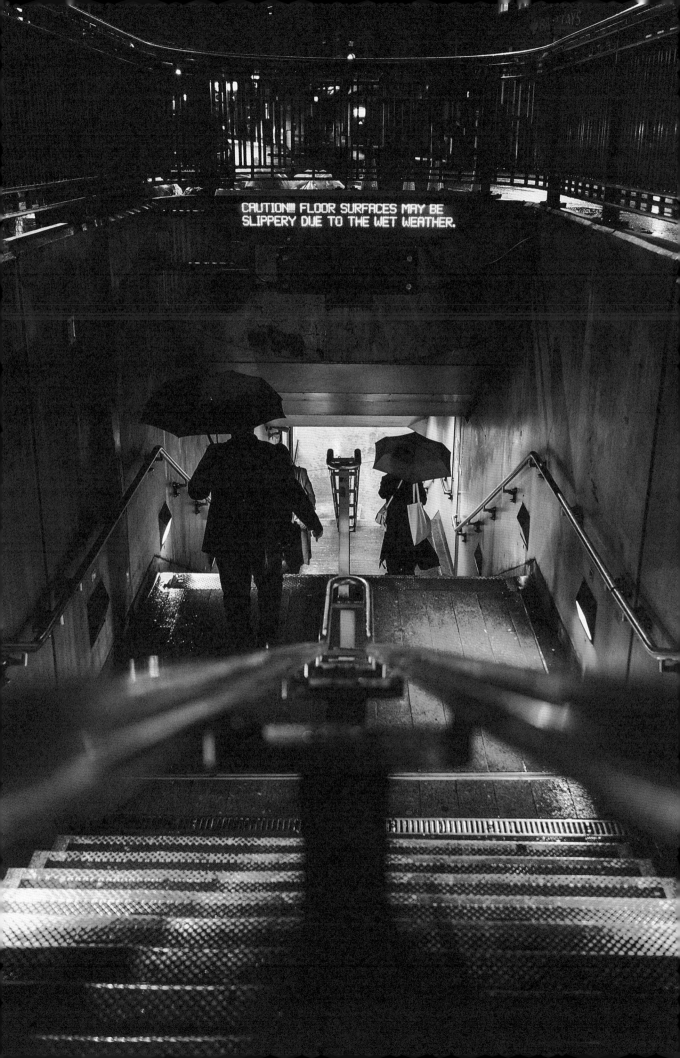

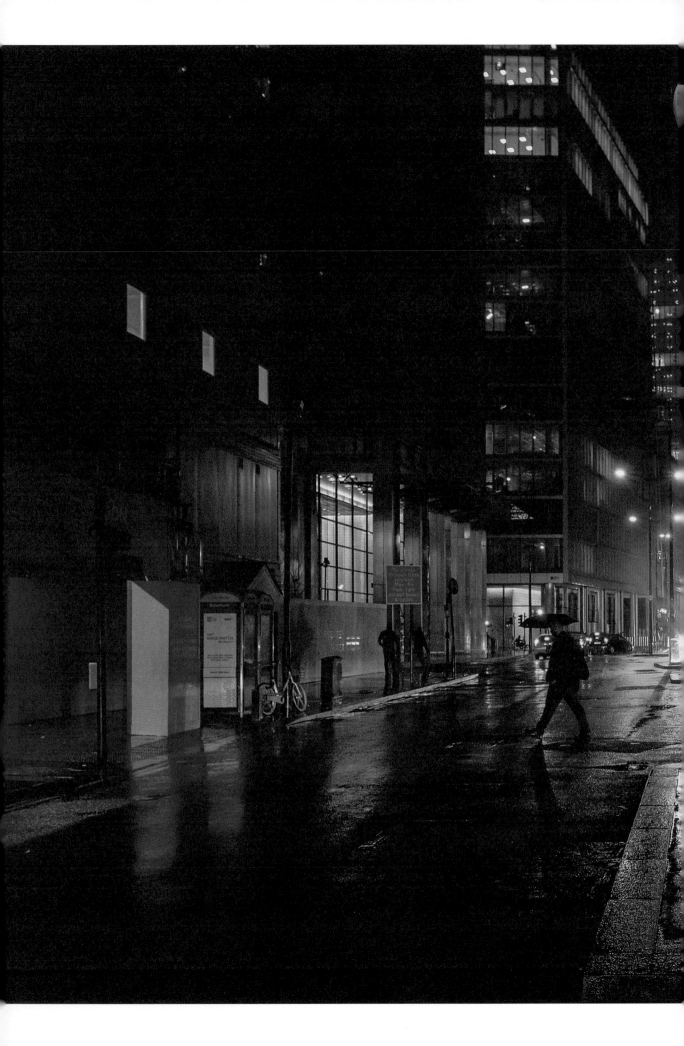

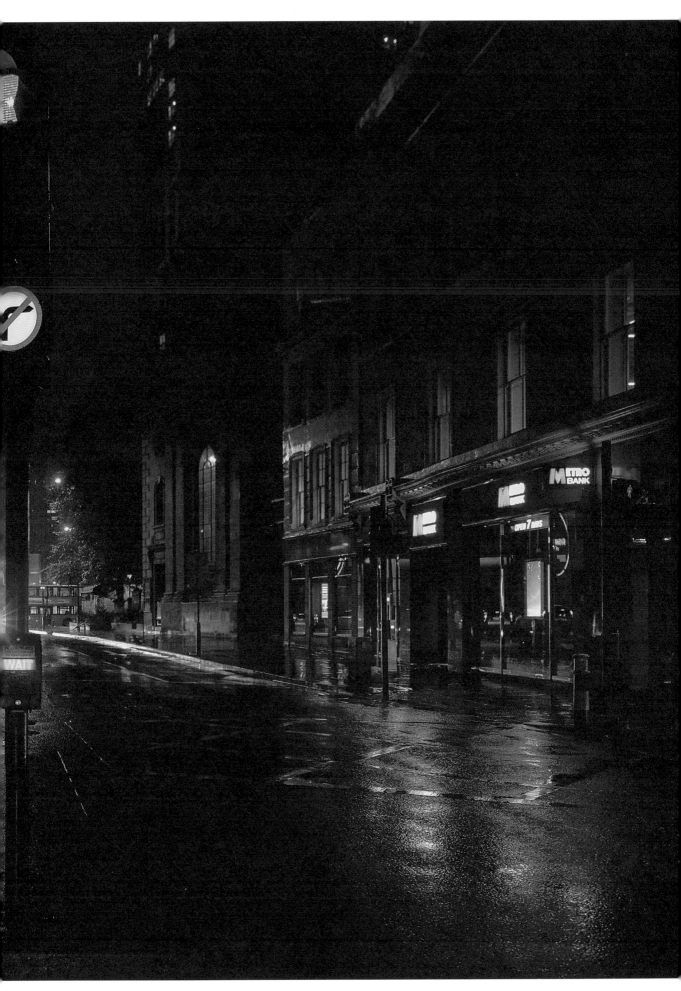

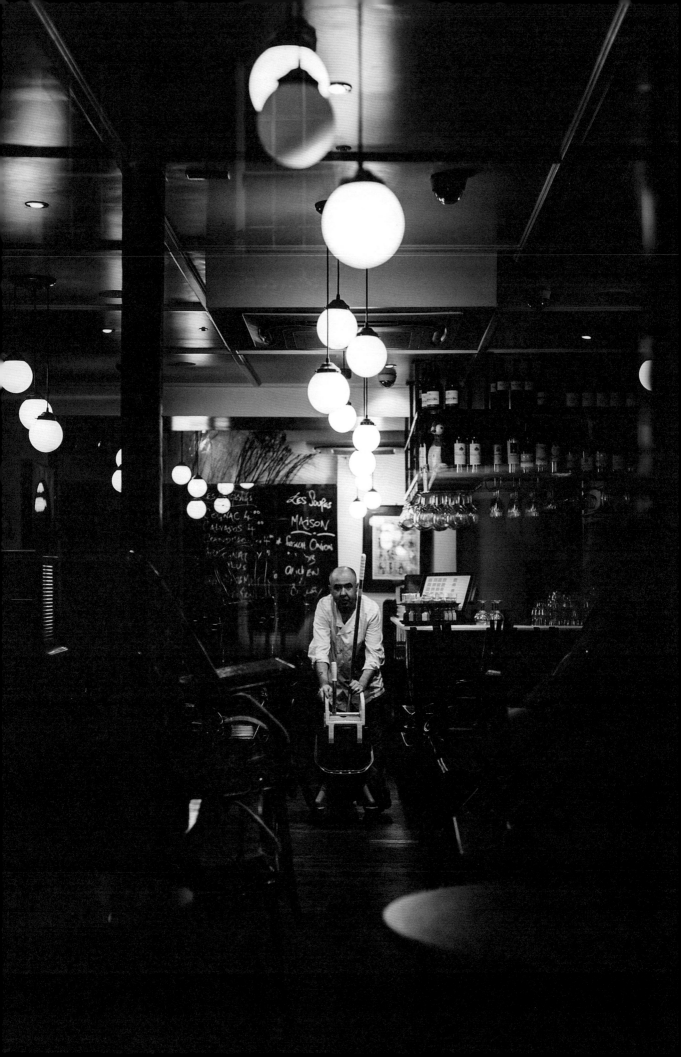

POSTCARDS FROM ENGLAND

LOUISE McSTRAVICK

These postcard chimneys stand proud, strong like steel,

the arms of empire now soft and welcoming.

The smoke becomes a cloud to float on, high in the skies

of prosperity, a snapshot of opportunity.

We sunbathe in ships shadow, absorb its promise

of hope, for young minds shown for the first time,

that the world does not end,

at the line where the sea meets the sky.

When it is our time, on our ship, our ears adjust to the sound

of voices that sing the song of the freedom beyond

the horizon. Our prayer offered to the skies.

I thought I was alone in this journey but the voices

speak familiarity like old school friends.

You cannot quite put a name to the face,

but it reminds you of that time and that place.

The postcards did not show that breath

could appear like a duppy. Condensation

caught by cupped hands in front of face,

you get any warmth you can take in this place.

If they had told me, I would have brought a coat.

Train from Southampton to Paddington.

On the left, I see chimneys aplenty.

Standing tall on buildings strong like steel,

more factories than they have people in the

West Indies it seems.

My sister laughs at me and with her words that

cut through picture postcard memories, she tells me

that these factories are homes!

Here they all have chimneys, burn coal,

breathe warmth in thick air.

My words stick in the back of my throat.

I learn the ways of this land of thick chimney smoke.

Our bodies speak rejection without our mouths open.

It seems this body wears judgement like it was made for target practice,

stood in front of doors locked from the inside.

I whisper words that land soft into ears of those

who fear our presence is too loud

who see the world in black and white.

Where I come from we had so many colours I realised

they spoiled my eyes.

There is no longer a line where the sea ends and the sky begins.

This line has been replaced by chimneys, smoke stretching

into the heavens robbing oxygen from mouths that once spoke of ships.

I breathe this air that does not seem to care for these bones,

I send postcards of chimneys to the people back home.

———

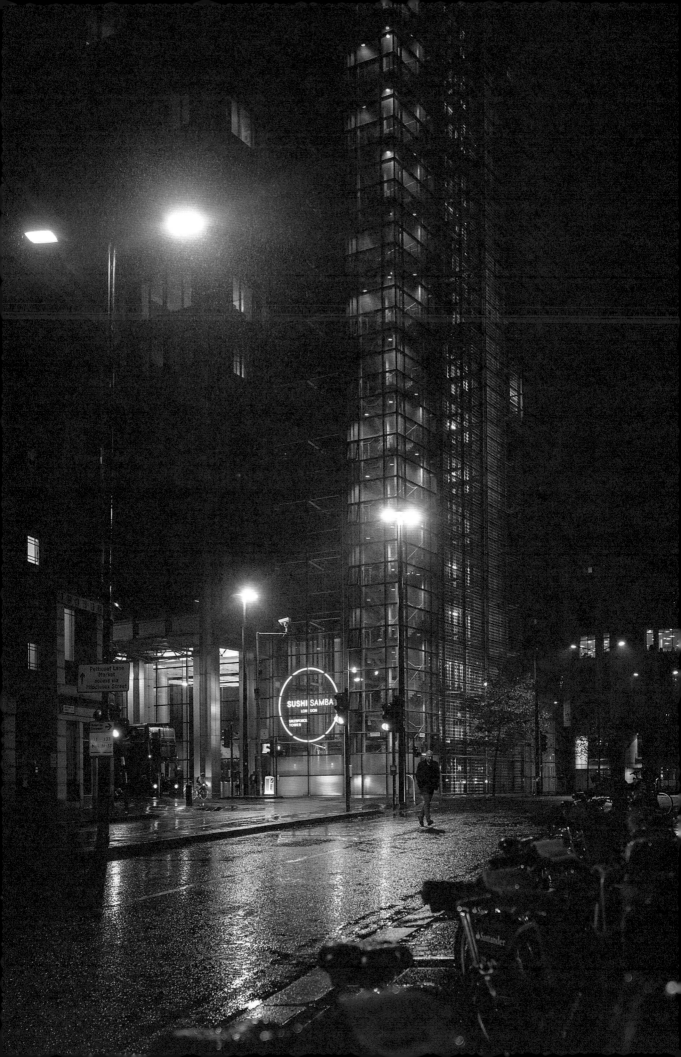

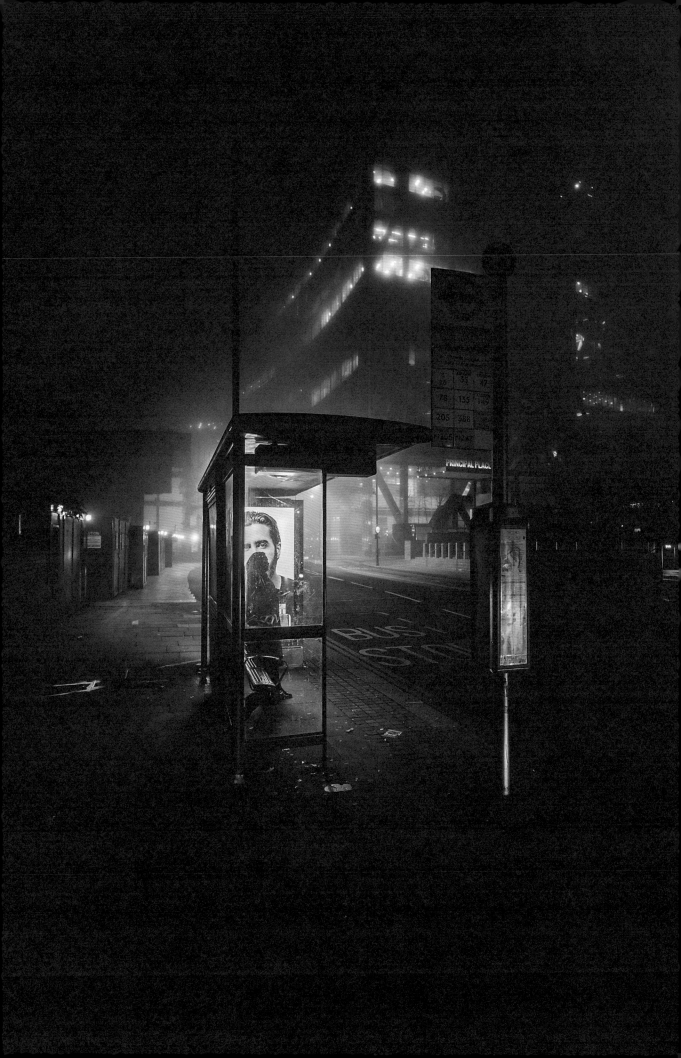

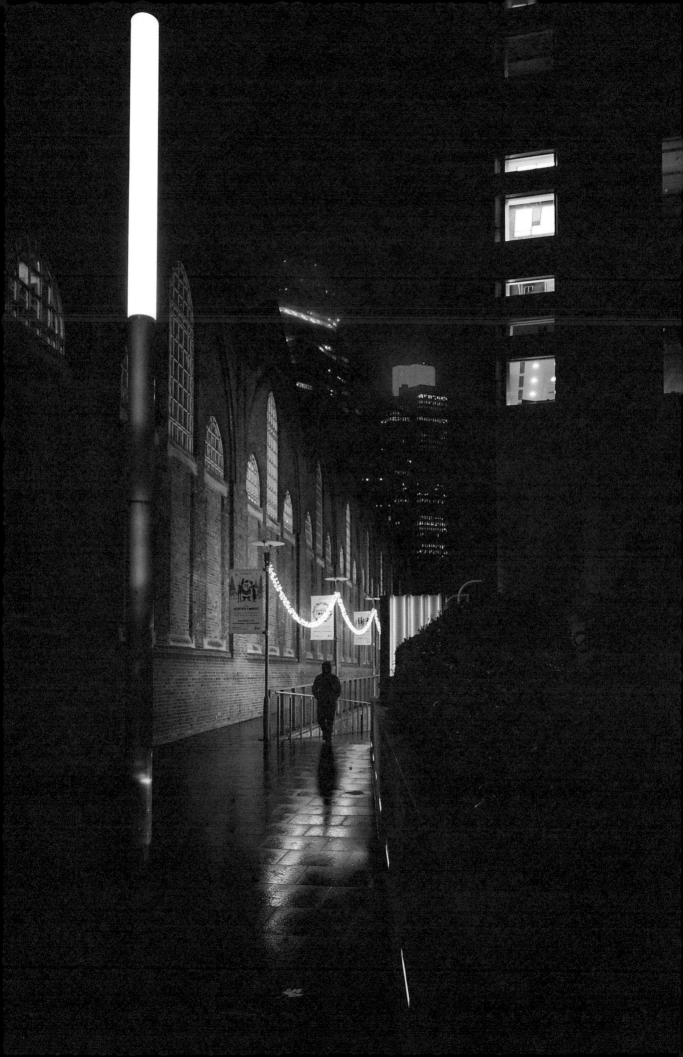

WALK ON BY

ELENA ASHTON

You walk on by

With the neon lights filling up your eyes to the brim,

The city turns so silently, looking up to the skies which stand deadly still.

So we pack it with excitement and noise to turn away from our worries and our strife

Fulfilling what your body begs for, the ecstasy true to your insides.

Big Ben churns out songs to the hour, but this time only tells the few seconds we

really have left

A glimpse of the real you in the murky water as it strikes ten.

For just a minute, the empty drains your veins

Seeing shadows deep in swirling blackness

Or is it your reflection, looking back at you,

The one that always stayed true?

That's the thing about London,

It stands so strong and with ambition

That we turn to look for the secrets that crumble

The humble city, back into the stone it was built from.

Instead, we find the many untold truths of our deepest minds

Lapping at your heart, pulling at the strings

And it makes you think about things

You never really knew existed.

So, as you find yourselves in the darkest streets, stumbling over the cobbles,

You must know that this place holds the blackest magic.

The one that challenges your thoughts every day, the depth of your compassion and

your guilt.

They decided that we would hide them in the mortar that builds our structures, and the

bricks that build our homes,

Democracy standing true to our core.

But you must look away,

Because with this 'democracy' you also signed away the right to uncover the depths

of the skyscrapers,

In this place that we call,

London.

———

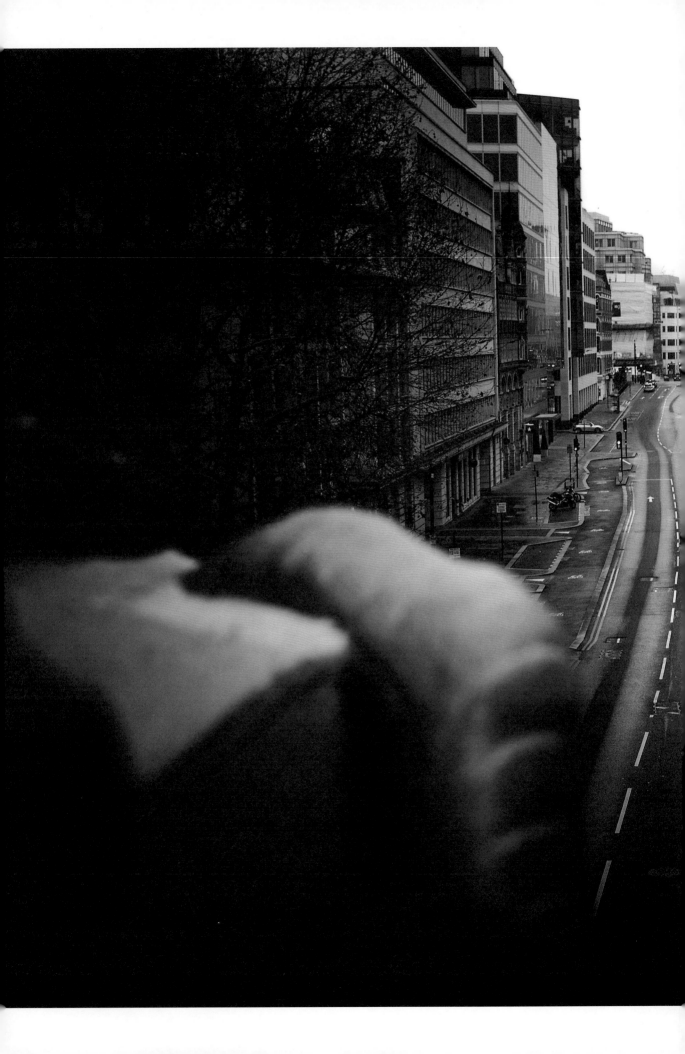

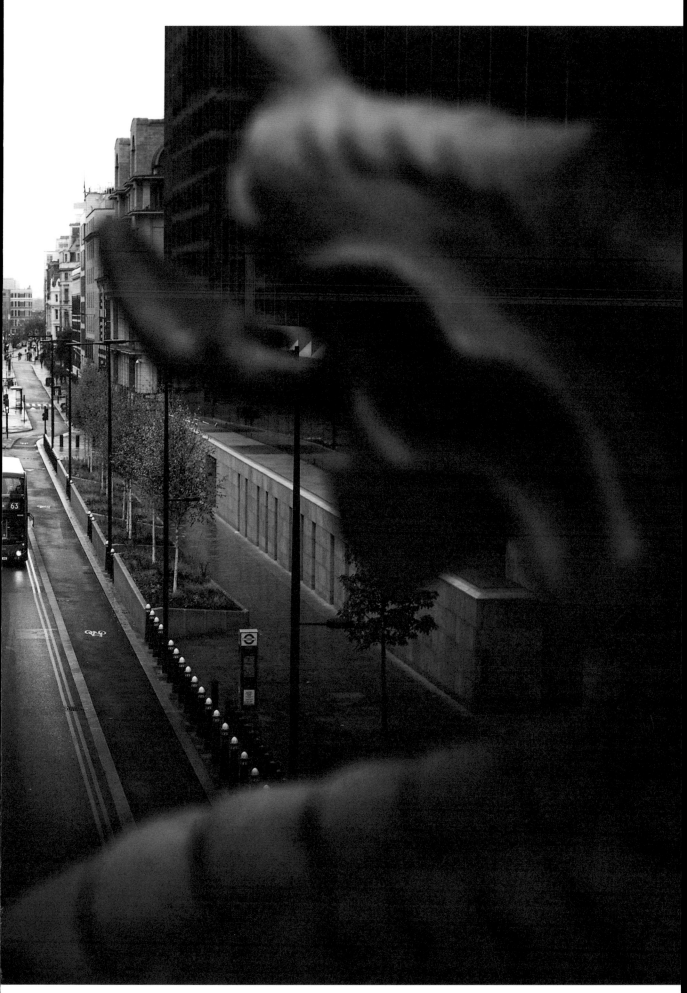

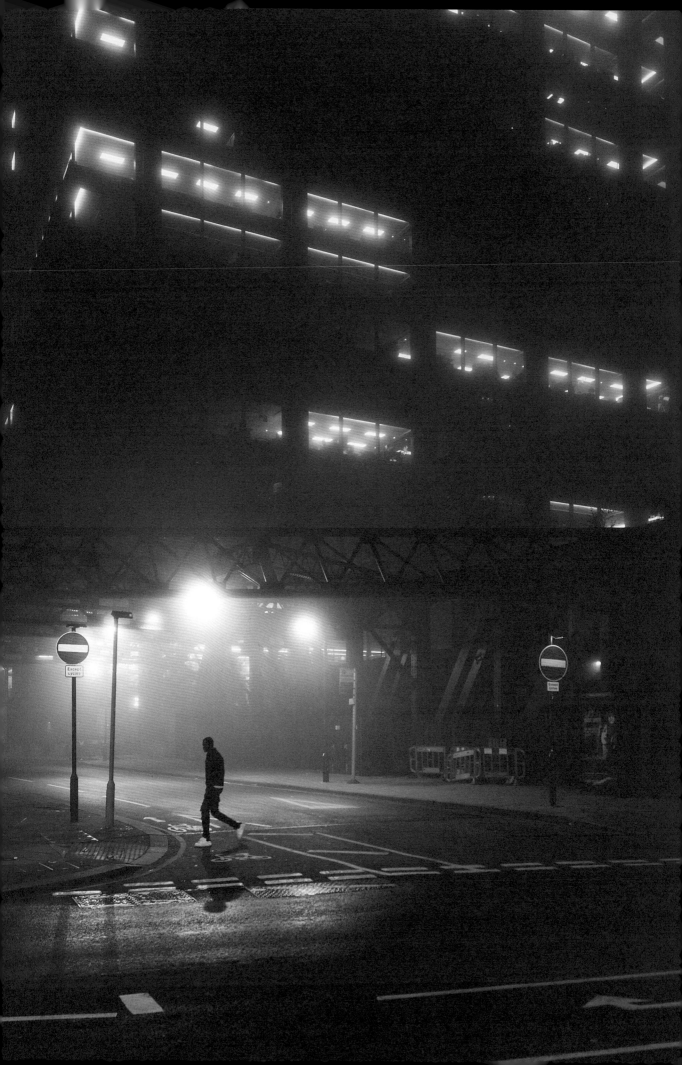

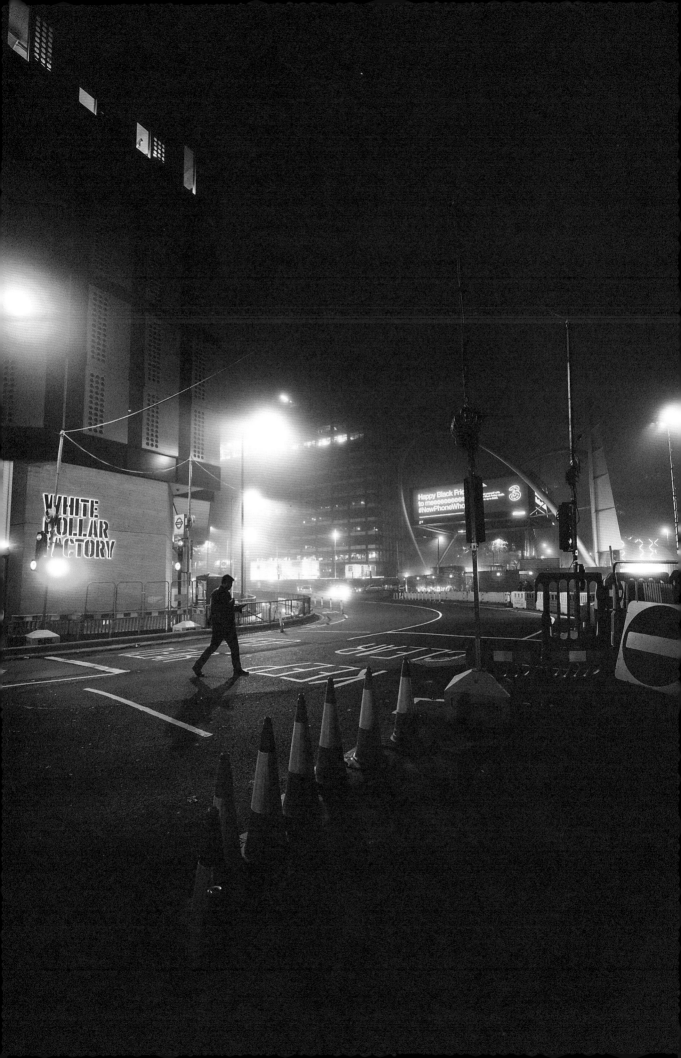

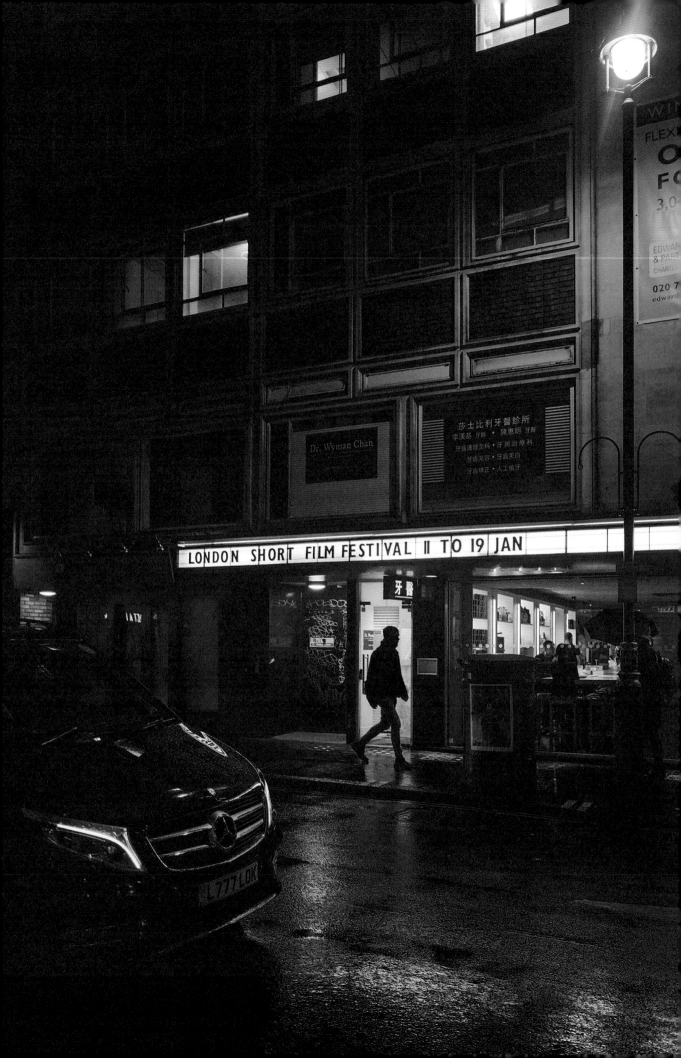

AFTERWORD

CHRIS HOLMES

The premise of *Hidden in Chaos* is twofold; visually capture moments of rare solitude within this city, and pair them with poetic perspectives on personal events hidden amongst London's chaos.

London is a staggeringly divine city, a city of cultural significance, a showcase of vibrant idiosyncrasies, an epicentre of unquestioning embrace. It can be hard to get a sense of a city as famous as it is honest and raw, purposeful and deliberate. The poetry here strips back the surface to reveal the naked view of respect, love and sincerity you won't find on postcards, but is shared by its tenants. Local or visitor, London courses through your body as if its rainbow-coloured system of underground veins is somehow intrinsically linked to your own.

As a nonnative Londoner, having moved here in my early twenties, I'm fortunate to have the benefit of seeing both of London's faces: its *grey* and its *glow*. Because London has moulded rather than made me, I'm able to remain in awe of every street corner, every character and every cold crevice of this crowded city. And it's this admiration that drives me to freeze these moments; to share the lesser seen and the overlooked, with a foreground of spectral, fleeting humanity.

Often waking before the city has yet slept, I witness its transition in real time from a place of eerie desertion to a circus of rhythmical chaos; darting feet, cursory conversations, metronomic transport, each and all signalling that London's eight million strong orchestra is awake.

The dramatic London backdrops are only co-stars; its people and its weather are the leading characters. Either element enriches a scene, shaping and deepening an image's atmosphere from merely pleasing to texturally plentiful. That's what I hope you'll have seen through these pages, London's truest qualities – the streets it owns, and the people it's borrowed.

This book has been five years in practice, twelve months in conception, eight months in creation, two months in development, three months in its build, eighteen poets, twenty-four poems, one street festival, thousands of photos, countless strangers, hundreds of miles walked, incalculable collective hours of thought, conversation and communication, all coalescing into this visual and beautifully poetic end.

This has been *Hidden in Chaos*; it's been an honour to share it with you.

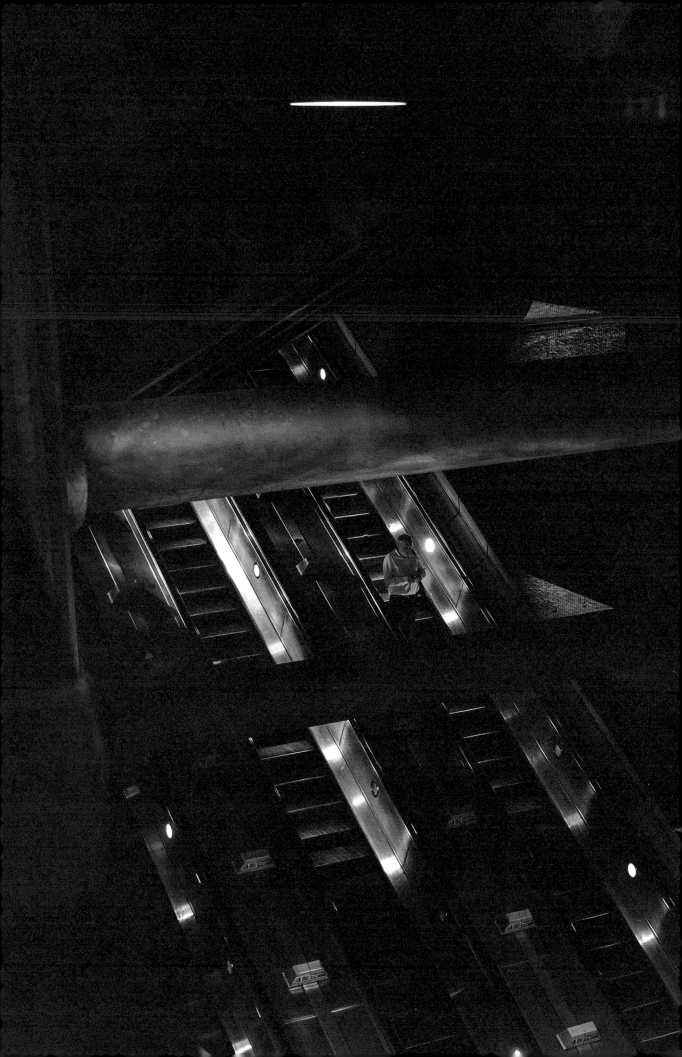

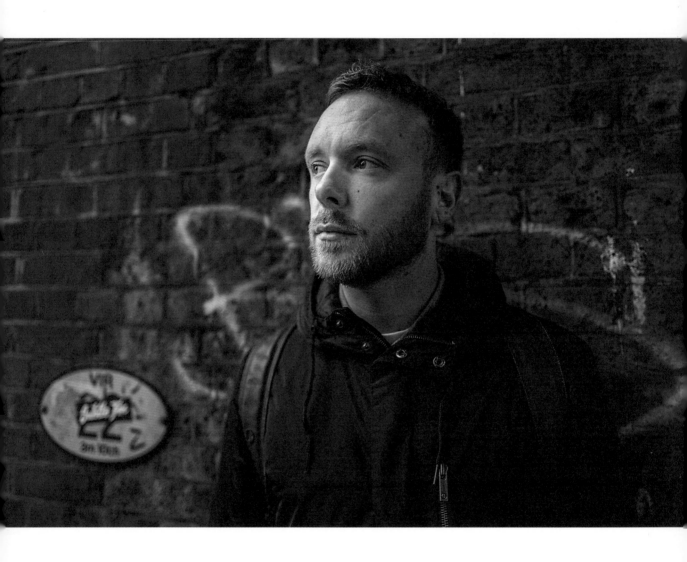

Photo by Tom Maday

CHRIS HOLMES

Now based in London, Chris Holmes was born and raised in Nottingham, in the center of England. Always pursuing creative hobbies as a kid, Chris could invariably be found with a pencil or pen in his hand, until he picked up his first pair of drumsticks and music took over. While he dreamed of a creative career, he followed a more traditional path throughout his school years, eventually moving to London and becoming involved in the live-music scene there.

Chris's passion for photography flared to life on a work trip to New York in 2014. Exploring Manhattan with his iPhone in his free time, he studied scale and composition, fascinated by the city's cinematic qualities. Soon he was searching out images on every holiday, commute to work or trip to the shops, with or without a camera in hand.

Encouragement from friends and family — including the gift of a new camera from his wife — inspired Chris to invest fully into photography as his craft and personal outlet. Completely self-taught, he's learned both photography and digital editing through trial and error, studying images from other photographers to analyse why they'd chosen a particular composition and how they'd achieved the final image.

Chris is naturally attracted to scenes with a high contrast of light and dark. His dramatic images have gained him international attention, from inclusion in various publications with Mendo (Amsterdam) and Trope (Chicago) to displayed pieces in an exhibition curated by Art of Visuals (New York). He continues to challenge himself to seek out fresh views of the familiar.

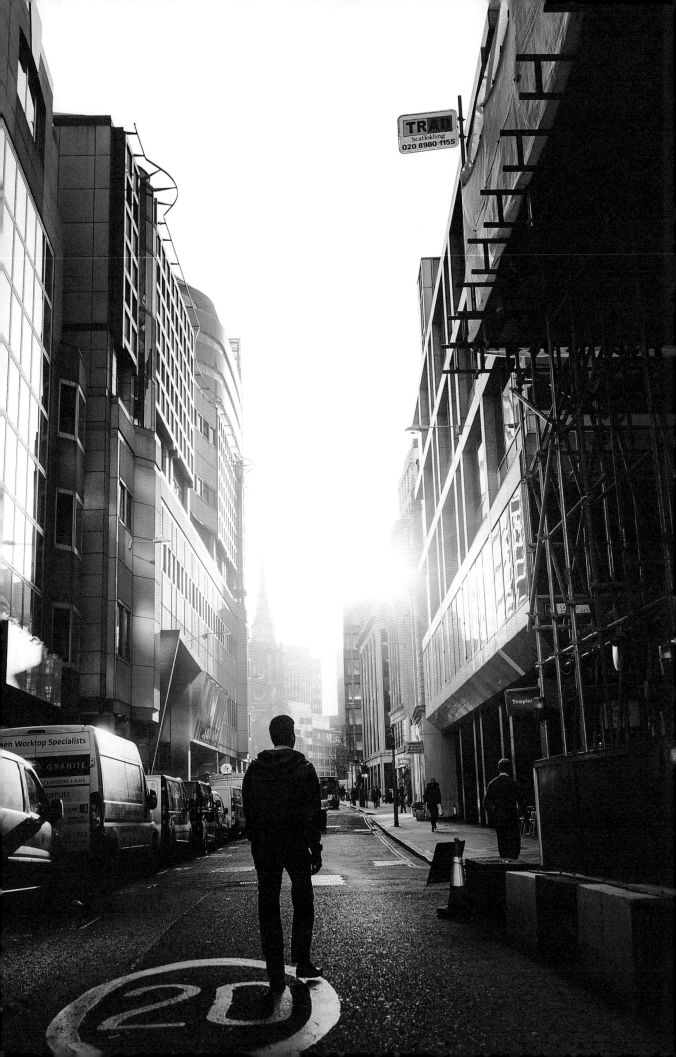

ACKNOWLEDGEMENTS

To my family, thank you for always allowing me the freedom to try and to fail; thank you for your unrelenting belief throughout my years.

This process has required absence, distraction and space, so to my infinitely patient wife, you have offered me those totems in spades and driven me out of doubt countless times through your unconditional support and counsel.

Sam, Tom, Lindy, Lucy, Kathy, Michelle, Scott and all the Trope family, there are no words that will ever cover my gratitude to you all.

This dream has not only been made completely possible by you but unforgettable because of you. It'd be amiss of me not to give you a solitary mention, Sam. You have created something beautiful, far and above these books; you've created a community, a platform, a narrative and you've given me belief, faith and now legitimacy. Thank you.

The Maday crew, Terry, Oscar and Jeremy, your energy is infectious, our time together and the experiences we shared will forever stay with me; after all, we'll always have Jammie Dodgers.

My dear friend Ash, you've driven this concept into a reality. Without your honest guidance, valuable time and overwhelming talent this would still just be a conversation.

To the poets, thank you for enriching this journey and ultimately making this book what it is. I'm honoured that we share these pages; you deserve the world to stand up and listen to your words.

My fellow Trope photographers, you were my idols long before and now we share shelf space together. Thank you for continuously raising the bar and inspiring me and so many others. Keep changing the game.

Finally, this book is dedicated to all that have ever believed in me, we've shared this journey together.

This is for you.

HIDDEN IN CHAOS POETS

ELENA ASHTON

is a young poet and spoken word performer from Stepney in East London. She has performed at London's StreetFest, been invited to speak at City Hall, and was a 2019 regional finalist in Jack Petchey's 'Speak Out' Challenge. *Hidden in Chaos* is her publication debut.

127

SHEZ CHUNG BLAKE

is a mother, teacher, writer, book nerd and word artist from London. Inspired by the vibrant lights and extremes of her home city, her poetry reflects and articulates her eclectic life, loves, ponderings, celebrations and frustrations of being a single BAME female during politically turbulent times. She was long-listed for the New Voices in Poetry prize in 2019 and her first poetry collection around the issue of female empowerment will be published in early 2021. She continues to perform around London and at festivals across the UK and deliver poetry workshops in primary schools.

89

TROY CABIDA

is a London-based Filipino poet and producer. His poems have appeared in *TAYO*, *harana*, *Bukambibig*, *Cha: An Asian Literary Journal*, *Ink, Sweat and Tears* and the Macmillan anthology *Slam! You're Gonna Wanna Hear This*. He has been a member of the Barbican Young Poets and Roundhouse Poetry Collective. Producing credits include open mic night *Poetry and Shaah*, his debut show *Overture: An Evening with Troy Cabida* and *Poems for Boys*. His debut poetry pamphlet *War Dove* (Bad Betty Press, 2020) explores Filipino identity, relationships and life in London within the first year after coming to terms with one's sexuality.

25

LAURA CORNS

is a South London-based poet, performer, DJ and freelance education editor whose work mostly explores the complexities of experiences outside of the dominant narrative around sexual assault, navigating the stages of healing and moving forward by writing her story into the silence. She also writes on the topics of grief, suicide and the female experience, along with exploring her unwavering love of London. Her work has appeared in *Crooked Teeth* (2018) and *Fire* (2010). She has been a featured performer at StreetFest London 2019 and That's What She Said.

37

PAUL CREE

is a spoken word artist, rapper and cofounder of hip-hop theatre company Beats & Elements. He's performed at Bestival, Latitude and Edinburgh Fringe and his work has featured on BBC Radio 1Xtra and BBC London. He has written and performed two solo shows, *A Tale From The Bedsit* (2013) and *The C/D Borderline* (2016), as well as co-written and performed in the critically acclaimed Beats & Elements shows *No Milk For The Foxes* (2015) and *High Rise eState Of Mind* (2019). In 2018 he published *The Suburban*, his debut collection of poems and stories, with Burning Eye Books.

63

CAROLINE DRUITT

facilitates classes and retreats around London exploring yoga and creativity. She credits combining her daily writing practice with movement for igniting her love of writing poetry. Caroline's work contemplates the human experience, often through the use of surrealism and rich imagery, exploring themes of loss, memory, womanhood, sense of self and relating to others and the places she inhabits. In 2020, Caroline launched her own monthly poetry night in collaboration with Pages, an East London bookshop stocking an eclectic selection of books by women, trans and gender diverse writers.

81

GEORGE DUGGAN

is a poet and writer based in East London. He graduated with a degree in English Literature and Film Studies from Queen Mary University of London in 2019 and has since become a Writing Room alumnus as well as a regular performer on the London circuit. His work tends to investigate the hidden significance in our often disregarded memories of youth.

45

SAM EL-BAHJA

is a teenage poet and spoken word artist of Moroccan and Thai descent. She was a 2018-19 regional champion in Jack Petchey's 'Speak Out' Challenge with full marks in each category, the first student in her school's history to win this title. She has performed at StreetFest and been featured by Dodo Modern Poets, and is currently at work on *Silver Smile*, a short film featuring her poetry.

93

TOM GILL

mixes humour and heart with raw lyricism, developing his storytelling style as a resident artist at Camden's prestigious Roundhouse. He has performed on eclectic stages from Latitude Festival to Ronnie Scott's Jazz Club, and is the former Farrago UK Poetry Slam Champion. His debut solo theatre show *Growing Pains*, commissioned by Battersea Arts Centre, enjoyed a sellout run at Edinburgh Fringe before transferring to the Royal Exchange Theatre in Manchester and then touring the UK in 2017-18. Tom has written for Channel 4 and Sky One and is developing his second solo show supported by Arts Council England.

109

BIZHAN GOVINDJI

has written about the Tube, knuckles, WhatsApp flirting, and how amusing he finds the question 'Where are you from?'–particularly when followed by 'No, I mean where are you *really* from?'– and has performed at spoken word events in London, Hong Kong and Cambodia, including Tongue Fu, The Moth, Word Up and Sofar Sounds. His Instagram poetry project, @HaikusForMillennials, tries to squeeze dry humour into seventeen syllables. It's been described as 'Rupi Kaur crossed with Bojack Horseman'– a compliment he knew would be the perfect humblebrag to slot into his bio one day.

IMOGEN HUDSON-CLAYTON

works as an actor, director, teacher and poet across the UK and internationally. Currently she is one of the core acting tutors on the Acting BA (Hons) degree at Rose Bruford College. Imogen is the associate director of Chaskis Theatre, a transcultural theatre company working to encourage empathy across borders, and associate artist of the Quarter Too Ensemble, committed to producing new and accessible theatre, workshops & collaborative community-based projects. Her work as a poet often explores womanhood, identity, sexuality, grief and belonging.

DANNY MARTIN

is a London-based spoken word performer and storyteller who aims to share people's truths through wordplay and rhyme. A 2019 Words First finalist, his work has been featured on BBC Radio 1Xtra and published in various anthologies and projects. 'In a world that is evolving faster than we can sometimes comprehend, humanity can be lost and I hope through my work and range of different styles, there is a realness and authenticity to the stories I portray; a gogglebox of poetry if you will'.

LOUISE McSTRAVICK

is a writer, teacher, and proud Brummie. She has featured at events in London, Birmingham and Amsterdam including London Literature Festival, Beans, Rhymes & Life and StreetFest, as well as reading her poetry on BBC Berkshire. She has been published both online and offline, and her debut chapbook is due for release in 2020 with Fly on the Wall Press.

AALIYAH ORRIDGE

is a young poet and author, native to Jamaica and now growing up in Britain. The fusion of experiences and cultures from her background is one of the main influences in her poetry; the effects of leaving home and the complex feeling of detachment from that home, while also becoming attached to a place that doesn't feel like home.

ASTRA PAPACHRISTODOULOU

is an experimental poet and artist based in London, merging poetry and visual art to create unique visual-textual objects. Astra is the author of *Stargazing* (Guillemot Press, 2019) and *Blockplay* (Hesterglock Press, 2019) and recently co-edited *Temporary Spaces* (Pamenar Press, 2020), an anthology of visual poems. Her work has appeared in *Ambit Magazine* and *The Tangerine*, and has been translated into Spanish, Russian and Slovenian. Astra curates visual poetry exhibitions across the UK as part of Poem Atlas, and her own visual work has been showcased at the National Poetry Library and the Poetry Society's Café.

ABDUL PATEL

is a writer, poet and actor from Hackney, London, now residing in South West England. Abdul has performed his poetry on stages such as BBC1xtra, the Cheltenham Literature Festival and Palestine Expo. His writing has been published in various online anthologies for short stories and flash fiction. Abdul has also published two books: *Native*, his debut novel, and *The Ghost of Shaolin*, a novella. Abdul recently featured in *The Informer* alongside Joel Kinnaman, Common and Clive Owen.

BEN SEE

is a singer and composer from London. Ben's music has been played on BBC Radio3, BBC London and Resonance FM, and he was chosen as one of Tom Robinson's 'Fresh Favourites of 2015' on BBC6Music. Recent compositions include an #AdoptAComposer collaboration with Stoneleigh Youth Orchestra and a large-scale choral work for the Whitstable Biennale. Ben is currently working on his debut album *blink blink* and an ongoing collection of lyric poems, alongside running LaLaLa Records, his own record label for emerging composers, performers and ensembles.

JANAY STEPHENSON

is a native Floridian and instinctual nomad, currently based in Brooklyn. Her work has been featured in *Shado Magazine* and on her own blog, Always Flying Solo. She gathers inspiration from personal events (especially the tragic ones) and stories told to her by the fantastic characters she's met around the world. Contrary to the average successful writer, she never writes if she doesn't feel like it and hopes to someday finish a film and complete a book.

LCCN: 2020935071
ISBN: 978-1-7326936-8-5

Printed and bound in China
First printing, 2020

Trope Publishing Co.

+ INFORMATION:
For additional information on
the Trope Edition Series, visit
www.trope.com

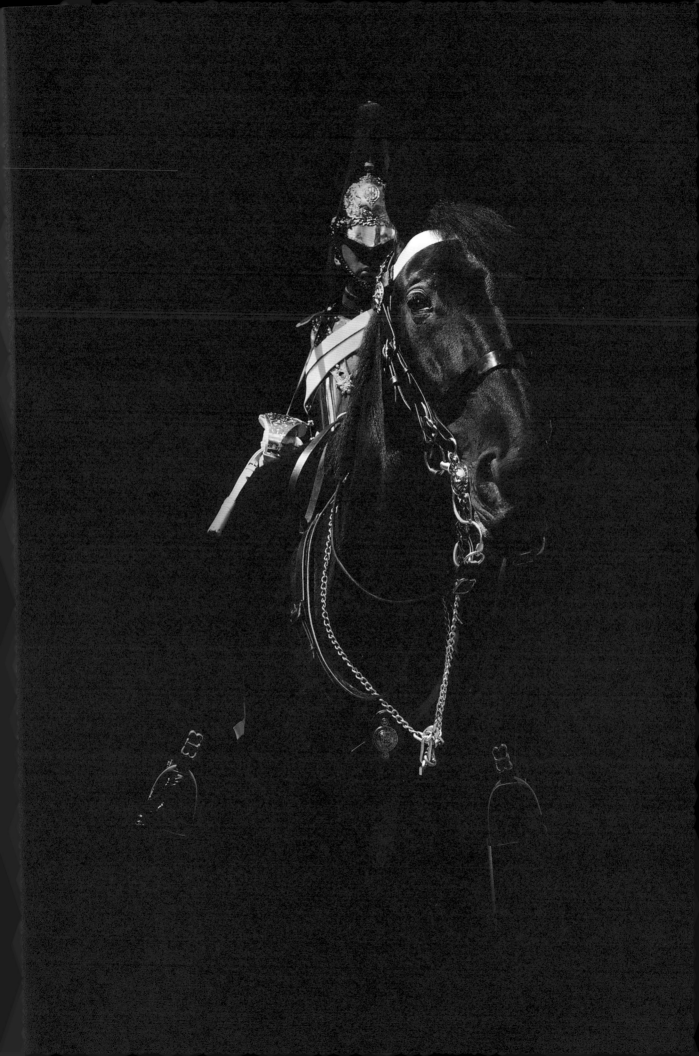

TROPE

TROPE EDITION

VOLUME V